Art, Life
and Everything

A memoir

Edited by Anna McNay

design © 2019 susak press
www.susakpress.com

Published by TRYPTIC
Designed by SUSAK PRESS

Typeset in Nimbus Sans

Printed for Tryptic in the UK
www.trypticbooks.com

FIRST EDITION
10 9 8 7 6 5 4 3 2 1

ISBN-13: 978-1-5272-4216-6

SUSAK press

Art, Life
and Everything

A memoir

JULIE UMERLE

With thanks to everyone who encouraged me to write my book.
It has been nine years in the making.

Contents

Foreword

I have known Julie Umerle since she was a child, and have always been impressed by her courage, determination and dedication to her chosen world of visual art.

Her writing, therefore, came as a surprise. The initial draft of her autobiography was a tentative and sketchy first attempt at this difficult form. But she has expanded and deepened this into a thoughtful and arresting narrative, notable for its lucid naturalness, for its stylistic economy and for an unflinching response not only to the physical and psychological problems of disability (which she characteristically minimises), but, most tellingly, to the art world: an honesty which may in part result from the long challenge of her childhood.

There is no trace of self-pity or self-delusion here. The outcome is a forceful and fluent narrative, in which the hopes and dilemmas of the aspiring artist's life will be absolutely recognisable to anyone who has undergone them. When her story achieves touching effect, it does so through the mediation of a steadily honest mind, with no hint of pretension.

Colin Thubron CBE
Travel writer and novelist

Artist portrait. 1978. Falmouth, Cornwall

Chapter One | **Real Life**

In the late 1970s, recently returned to London from Cornwall with a first class honours degree in painting from Falmouth School of Art, I was 23 and excited by the prospect of what lay ahead. I knew the joy of painting and believed that with enough effort and a little luck, I would become an artist. However, as a wheelchair user, I would face many additional challenges.

I moved back to my family home in Walthamstow, east London, which was not my original intention. Previously, when my partner and I lived in Falmouth, we had planned to move in together when we returned to London, but our relationship had recently ended. Although I had enrolled on the waiting lists for two artist-studio groups before arriving in London, in the short term, I was unable to continue my painting practice from home. Our family home was a small two-bedroom, terraced house; I slept in a room downstairs and there simply wasn't enough space for me to work there too.

I was resigned to a long wait before I was able to find affordable studio space, but my mum tried to think of other ways around the problem. She contacted Zuleika Dobson, who was then director at Camden Arts Centre. Zuleika agreed to visit me at home with her husband Frank Dobson (the Labour MP) to discuss what options might be available. Their suggestion was to convert our small living room into a studio and start working there. Unfortunately, my family would never have agreed to such a plan.

Mum also had the idea of contacting the London Docklands Development Corporation (LDDC), which was by now redeveloping vast swathes of land towards the east of the city. At that time, many artists were working in huge industrial spaces in London courtesy of the LDDC, in derelict sites such as Butler's Wharf. As a result, I was offered a flat

and studio space in Docklands, but I turned it down because I was hoping to find somewhere a little less remote. I could not use public transport (an inaccessible mode of travel for disabled people at that time) and I could not drive, so I could see myself becoming even more isolated if I moved outside my comfort zone. More ironic is the fact that I now live in Docklands – of course, that part of London has changed enormously since the 1970s.

I had to build myself a new support system outside of the art world I knew. Fortunately, my friend Craig was also living in London. We had met as students at Sussex University six years previously where I had been reading French Literature and Craig was studying Social Anthropology. I left Sussex to pursue my love of painting, enrolling on a foundation year at art school; whilst Craig now worked at Release, the charity co-founded by Caroline Coon, set up to help people arrested on drug charges. Craig introduced me to his colleagues at Release and I was immediately welcomed into their group.

After a short while living at home, I heard through my ex-partner who had moved there with his new girlfriend, that a couple of rooms were available on the ground floor of a south London squat. And, despite my initial reluctance, it seemed a solution to my problem.

I decided to go over to the house to take a look and meet the other occupants. The squat was in St Alphonsus Road, near Clapham Common, with a church of the same name at the top of the street. It was part of a row of dilapidated houses, many of which were boarded up – one of several houses owned by the local authority that had been left in extreme disrepair. The house did not have a bath or shower but did have running water. The electricity meter had been rigged so at least there was free light and heat to ward off the damp.

Apart from the two people I already knew in the house, I was aware only that the four others who lived there were addicts who sold heroin to support their habits. I was rather uncertain of what I would find or how we would get on.

I spent the afternoon on Clapham Common enjoying the last of the sun before going over to the house in the evening to meet the other occupants: a South African, an American and their partners. They didn't

look like your archetypal drug addicts and did at least seem to be in control of their habits. They looked 'elegantly wasted' and had a veneer of cool authority – after all, this was their house and their territory and they had the final say about who lived there.

In the master bedroom on the first floor there was a double mattress, a big television and a good sound system. That evening, we sat on floor cushions at the end of the bed, listening to music and watching television with the sound turned down. There wasn't much conversation. As the syringes and spoons came out, I feigned indifference, my eyes glued to the television screen.

Downstairs, someone lived in the front room, but the rest of the ground floor was vacant – the middle room, a small kitchen, a lavatory and a large room at the back. I decided to move into the squat and try to make it work. This was not the artist's life I had envisioned for myself, but I didn't want to remain living at home where I couldn't paint.

I moved into the house with my new kitten Astral, a few clothes and some art materials. A number of artists lived on the other side of the street, but I didn't get to know any of them because our house was known as the 'druggie' house and viewed with suspicion by most of our neighbours. The squatters next door, members of the Socialist Workers Party, would lob empty bottles into the backyard outside my window when the music from our house became too loud.

It felt like living in a cave: my room had no natural light because of the brick wall behind it. There was an old mattress on the floor and no furniture. I was glad to have my kitten for company. At first, I spent most of my time making work on paper with pencil, crayon and pastel – covering an entire wall with my drawings. It was a great relief to be able to continue my practice, whatever the circumstances.

Then I cleared the back room, which was damp and filled with rubbish, to use as a studio, excited to have my own space to paint in. Again, this room had no natural light, but I enjoyed the opportunity to work on a large scale and stretched vast sheets of paper onto the walls, making paintings with emulsion, acrylic and charcoal. Eventually, I was able to move into the front room when the previous occupant moved upstairs.

This room had a big bay window looking out on to the street and was in much better condition. It was wonderful to have a room with natural light again, something I have never since taken for granted.

When friends came to visit, we would usually go out rather than stay in the house. Occasionally, I would be invited upstairs to watch the television, which was a big treat. I learned to ignore the behaviour of the others, as long as it did not impact on me. Of course, there was a succession of visitors to the house at all times of the day and night. The junkies rarely emerged from their rooms, apart from to buy drugs. They were sick a lot of the time and spent most of their time in bed. Sometimes their paranoia seemed to infect the house itself.

Fortunately, within a couple of months I had an interview with Acme, the artist's housing association, where I had been on the waiting list. I took my portfolio to be assessed by the directors at their office in Covent Garden, and was told there was the possibility of a house share coming up in north London that might be suitable for me – somewhere accessible where I could live and work. With this prospect in sight, I left St Alphonsus Road. It had only been a short-term solution to my problem and the squat was not a healthy place for me to stay, either physically or emotionally.

In the spring of 1979, I moved into the Acme house in Archway, north London, with Astral who had already moved home with me several times. At last my life seemed to be moving forward. The house was large and semi-detached with big windows in the front and a beautifully cultivated garden at the back. It looked very suburban but the houses were due to be demolished by the Department of Transport under a planned road-widening scheme for the A1. Acme had been given a short-term lease on the house while the fate of the road was decided.

Two artists lived upstairs (a married couple), while I had the ground floor to myself, but it was far from private. It wasn't really like living in separate units because the house wasn't a conversion. My upstairs neighbours had to walk through the hallway in the middle of my flat to reach the stairs. We shared the front door, the hall and the garden, as well as utility bills.

The artists upstairs were a little older than me and at a different stage in their careers. They had already lived in the house for several years and were very settled; they started a family soon after I moved in. I knew right from the start they would much rather have lived alone. They asked Acme if they could buy the house as licensed tenants, but, because of the uncertainty of the road's future, they were unable to and had to share it instead. Several artists before me had lived downstairs, although none had stayed long, so I was part of a transient group.

The house had level access and a ground-floor bathroom. It was one of Acme's better properties and even had central heating. Acme took one of the doors off its frame so that I could get my wheelchair into the bathroom, but, apart from that, there were no other major adaptions needed. My stepfather replaced the sashes in the heavy bay windows at the front of the house so I didn't have to prop them open with books; social services paved over a path at the side of the house so I could reach the back garden.

My studio, to one side of the red-flocked hallway, was a decent size and I was able to move all my canvases into the room and still have space to paint. I received a studio conversion grant from the Arts Council to install new strip lighting in my studio, replacing the poor lighting with colour-matching fluorescents, which was a vast improvement. This meant that I could also work at night if I wanted to. The house was not in the best condition and would have needed extensive repairs if it had been part of the private sector, but it was spacious and I was lucky to have been offered a place there at an affordable rent. In my bedroom, at the back of the house, a part of the ceiling had fallen away due to the badly installed washing machine in the kitchen above. From time to time, the washing machine would emit its waste into my bedroom, then the rugs would need to be hung outside to dry. There were also leaks in the ceiling of my living room and, when it rained, I would carefully position saucepans on the floor to catch the drips. Once, the entire ceiling of the lavatory crumbled to the floor through piles of rotten plaster and floorboards. From inside the house, we could hear the constant rumbling of the heavy traffic from nearby Archway Road, sounding like ocean waves.

I was desperately short of money but tried hard to focus on my painting now that I had the opportunity. I started by making small oil paintings, scaling right down from my usual-sized canvases (150 centimetres square) and working on 75 x 90 centimetre canvases instead. Perhaps it was a good discipline. I had been unable to paint on canvas since leaving Falmouth and it took a while to feel confident again. At first, I painted rather tentatively, nothing too ambitious, simply trying to orientate myself within the studio and re-engage with my practice. It felt good to be painting again.

My working life had been completely disrupted by three experiences in the past year – coming to terms with the end of a long-term relationship, starting a new life alone in London and trying to find somewhere suitable to live – so I found it hard to establish a routine. I was very unhappy in the house once the initial enthusiasm for it had passed. I think I hit rock

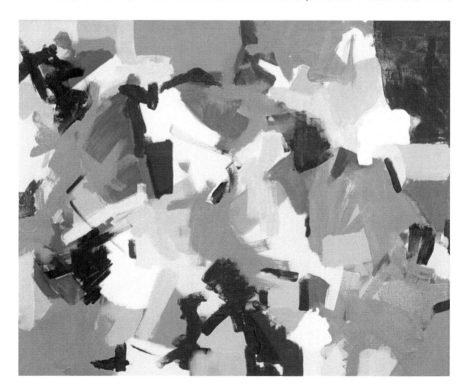

Untitled II. 1979. Oil on canvas. 75 x 90 cm

bottom when I was living there, struggling with my own demons and at my lowest ebb. It never felt like home to me, despite the fact that Astral marked out his territory in the house almost as soon as we moved in.

I couldn't seem to settle, finding it difficult to establish boundaries between life and work. I'd wake at noon and paint at night. I had finally attained my goal of finding a flat and a studio in London, which had previously seemed so elusive. But I thought of the house as 'desolation row' and, in that light, it seemed to acquire an ominous presence. I had still not entirely abandoned the free-living days of my life in the squat in Clapham, when there was literally no one to answer to and any behaviour was acceptable, but I found I had to conform now that I lived with people who weren't on the edge of society – as I felt myself to be. It took a while to make that transition and this was essentially the first time I had ever lived alone.

Often, I would go to the library in nearby Wood Green and come back with piles of books to read, pure escapism. I still loved being surrounded by books: it felt very comforting. I was trying to change my circle of friends too – several of the people I'd been close to in my first year in London were now no longer even acquaintances.

However, in 1980, a breakthrough with my work lifted my spirits. I had my first solo exhibition in London at the Car Breaker Gallery, a squat in the west of the city, after the director made a studio visit to see my paintings and immediately offered me a show. This felt like a step in the right direction because it had been so difficult trying to find somewhere to exhibit. Although outside the mainstream, this was a way of launching my career and the start of a valuable learning process.

The Car Breaker Gallery was part of the counterculture in an area of Notting Hill called Frestonia, originally home to 120 squatters, with many artists, actors, writers and musicians among its residents. Frestonia had declared itself a free republic and had even applied to the United Nations to provide peace-keeping troops for protection against the Greater London Council, which was threatening eviction. But I felt at home among all the anarchy and mayhem, enjoying the creativity accompanying it.

My first solo exhibition in London proved a memorable event. The opening day was rather shambolic. We hung the paintings in the morning then shared a meal in the gallery that evening, followed by the most dysfunctional private view I can remember. As it grew dark, we turned out the lights and viewed the exhibition by candlelight. Later, one of the residents gave an impromptu performance in the middle of the room. It seemed like the whole street was squeezed into the gallery that night.

The exhibition included a selection of paintings I had made in Falmouth as a student, alongside more recent work. Three of my tutors from Falmouth, who were teaching at the Chelsea School of Art, came to see my show during the two weeks my paintings were on view. My mum and stepfather, as well as one of my aunts, came too – having to climb through a window to get into the gallery when the director lost the key to the front door.

Despite this rather unconventional setting for the show, the exhibition allowed me to assess the strengths and weaknesses of my work and was extremely useful in gaining a perspective on my practice. I received lots of encouragement to keep going with my painting at a really difficult point in my life and this was important to me.

Afterwards, I continued to exhibit in alternative spaces for a while. I knew my work would take a long time to develop and I was not too anxious at that stage about my paintings being seen by the right people or in the right places. Although ambitious, I was also extremely critical. I had great self-belief and knew I would make progress over time. The most important thing, I felt, was just to keep painting.

I left the Acme house after 18 months and moved into a small garden flat in Tottenham, north London, where I converted the front room into a studio. My first experience of living in a live/work studio in Archway had been an unhappy one and I was hoping that things would improve in a different environment and in my own space, despite the fact that Tottenham was, in many ways, a far less desirable area of London.

I found the isolation of working at home troubling, but my priority was to make progress in my painting and I thought that having a studio at home was the easiest, most practical way to do so. I fully believed that

artists had to suffer for their work and didn't expect life to be easy as I tried to establish myself as an artist in London.

In 1981, I had my second solo exhibition, at a gallery in Hornsey, north London, where I sold my first oil painting – a 157 centimetre-square-canvas entitled *Number Nine*. Actually, all the works in the show were untitled and simply referred to in the order in which they were hung. The friend who bought the painting re-titled it *Number Nine Dream*. I felt so proud of that sale. Most artists rely on selling their work to friends and family in the early stages of their careers, While high-powered collectors usually follow at a much later stage. I was pleased to have at last started selling my paintings and thrilled that someone wanted to own one. I thought it was wonderful that my work had found a life for itself outside of my studio, and enjoyed seeing my painting installed in a domestic setting.

A significant development in the way my work changed after that show was that I began to give titles to my paintings after that show, naming some of them after places where I had lived. Many visitors to the show had expressed their dismay at being confronted with a whole exhibition of untitled paintings. They told me that titles helped them find a way into the work, so this was useful feedback.

In Tottenham, I was beginning to discover how difficult it is to live as an artist outside of an artist community. I missed the interaction with my peers and had never realised before quite how different our lives are from those of other people in the wider world.

For example, one evening I had been shifting some heavy paintings around my studio late at night, bumping them across the bare floorboards. The next thing I knew the police were knocking on my door; my upstairs neighbours had called the police to report a disturbance. The family upstairs didn't understand my way of life at all, but, of course, I would need to make compromises to adjust to theirs. I could see that I would have to think very carefully in the future about how my working practice affected others, which I must admit I had not really thought about before. They were lucky I was not a sculptor: painting is a relatively quiet activity.

I was making steady progress with my work, still using oil paints as I had at Falmouth. I also started using collage in my paintings, or adding beeswax to the paint to change its consistency. I didn't seem to be reaching a point with my painting where I knew exactly what I was doing. Most of the time it seemed as if I were stumbling around in the dark, moving from one idea to another without any continuity, but that is the nature of experimentation. I did consider at one point going back to art college to study for a master's degree, but it didn't seem to be the right time just then.

In 1982, I moved to a second garden flat in Tottenham, a recently renovated conversion. This flat was in much better condition than the previous one and more spacious. I hoped it might be a place I could settle. By now I was getting tired of moving. It seemed counter-productive and I felt that I needed more stability in my life. I converted the front room into a studio (as I had done on two previous occasions) and began to re-establish my studio practice, but again there were problems with the family who lived upstairs. They complained about the fluorescent lights in my studio, which illuminated the whole of the road when I painted at night, and they complained about my music. In fact, the family upstairs was rather intimidating, but I couldn't choose my neighbours. I felt I was living under scrutiny and knew quite early on that it was not somewhere I would stay.

Perhaps if I had lived in a block of flats rather than in a converted house, I would not have had as many problems. Sharing your front door and hallway with others doesn't allow you to completely define the limits between each other's lives and there is little privacy. A flat that has been converted without soundproofing, as mine was, is difficult to live in. Yet, at the other extreme, one of my sisters lived in a tower block on an estate and I could not see myself being able to live like that either.

In my continued attempts to find funding for my practice, I updated my slides and CV and sent out a grant application to the Greater London Arts Association. Jenni Lomax (who was later appointed director at Camden Arts Centre) was the arts officer who visited my studio to assess

my work. My application was successful and I was awarded a small grant, which allowed me to invest in art materials. This was the first real acknowledgment of my work by the mainstream and it made me feel that I had at last made some progress in my career.

My next exhibition, in 1983, was a group show at the Mario Flecha gallery in Islington, north London. The gallery had a good reputation and the show included work by several established artists, including Langlands and Bell. After the private view, my cousin Mandy, Craig and I went on to the Release offices in nearby Upper Street for our own private party. I came home in a taxi after celebrating the occasion, and later passed out on the floor of my living room. The next morning, I felt lucky to be alive and went out to nearby Broadwater Farm to recover, feeling very fragile.

At that time, as long as I was able to paint, which I did in a very orderly fashion, I didn't worry how chaotic other parts of my life were. I would spend most days in the studio anyway, and had established a regular working routine, but because I had not met any other artists in London, I had no one to compare my progress to.

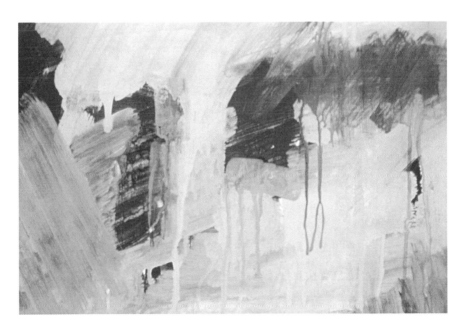

Untitled. 1983. Watercolour and gouache on paper. 37 x 52 cm

By now, I had been living in London for five years. The contemporary art world in the early 1980s seemed rather less exciting in London than the one I had heard about in Germany, where Gerhard Richter, Sigmar Polke and Blinky Palermo had gained recognition.

Although I didn't visit the Royal Academy's 1981 exhibition 'A New Spirit in Painting', I was very aware of its significance. It was an exhibition that captured the zeitgeist and heralded a return to figuration through Neo-Expressionism. The show included artists such as Francesco Clemente, Anselm Kiefer and Julian Schnabel, as well as the Scottish Expressionists, Jock McFadyen and Steven Campbell.

I had experienced a few difficult years since leaving college and was already beginning to feel a little daunted. My paintings, being abstract, were suddenly unfashionable and out of step with the current trend. However, my commitment to my practice did not waver and I was still excited by the act of painting itself. I then stopped to consider how much more I had to achieve.

Chapter Two | **Turning Point**

My work as an artist was developing slowly, at its own pace. There was very little I could do about that. I tried to stay focused, but there are often more important things in life than a career – as I was about to find out.

The year 1984 was fast approaching. It had always seemed like a landmark to me when I was growing up, looming far away in the distance and strangely significant because of George Orwell's novel, *Nineteen Eighty-Four*. For me, there was as much anticipation about that year as about the new millennium, but it turned out very differently from anything I could have possibly imagined.

On 11 January 1984, I was admitted to the Royal National Orthopaedic Hospital in Stanmore, Middlesex, for a spinal fusion. As a child, I had developed a rare autoimmune disease, transverse myelitis which paralysed my legs and left me unable to walk. My spine had gradually weakened over the years and regular X-rays at the hospital had charted its deterioration. I knew that I would be in hospital for up to three months and that the recovery time would also be lengthy. The operation would completely disrupt my life and I would have plenty of time for contemplation over the coming months.

Craig stayed in my flat while I was in hospital, visiting me regularly. Apart from my family, Craig was the only person I told about my surgery. For some reason, I didn't want anyone else to know – yet a three-month absence on my part would hardly go unnoticed. Once admitted to the hospital, I put aside all thoughts of my life outside and concentrated on getting through what I knew would be a rather awful experience.

The Royal National Orthopaedic Hospital, just outside of London, was housed in a dilapidated building but it was known for its clinical excellence. My orthopaedic surgeon, Mr Edgar, was very experienced,

and I had total confidence in his abilities. I had already had several consultations with him over the years and he had warned me that the operation was a delicate procedure that did not come without risks. It could even prove life-threatening.

I went through several tests at the hospital before the operation itself, which would be completed in two parts. In the first procedure, the surgeon would operate on my spine through my right side. Then I would need to lie completely flat on the bed before the next part of the operation a few weeks later. In the second procedure, the vertebrae would be re-aligned and secured with a fine titanium rod and screws in a feat of skillful engineering. I knew that I would need to wear a plaster cast for three months after the operation and an orthopaedic corset for a further three months after that. I had never had an operation before but looked on it as a necessity rather than an option. Without surgery, my condition would have deteriorated. I was quite pragmatic about the risks, although my mum, fearful of the consequences, wanted me to change my mind right up to the last minute.

As the time drew near for me to go down to the operating theatre, it was already too late to change my mind. Amid the strange surroundings and atmosphere of the theatre, I began to cry, frightened of what lay ahead. But as soon as the anaesthetic took effect, I quickly lost consciousness. When I awoke in the recovery room after the operation, my body wrapped in aluminium foil to retain the heat, my torso was completely numb. I felt strangely calm and serene (a result of the intravenous morphine), attached to several drips and monitors. My life was entirely in the hands of the nursing staff. I felt as if I were floating between two realities, my body had become quite separate.

After several days in intensive care, I was transferred back to the ward before the next part of the operation, which would take place a week later. In the meantime, I had to lie flat on my back and could not move at all because my spine had not yet been fixed into position. At least I had survived the surgery. In a further revision of the operation some 20 years later, I would come close to losing my life...

The pain encountered as the intravenous painkillers were withdrawn and replaced with morphine injections was beyond anything I could ever have imagined. Searing, unrelenting pain tore through my whole body as the numbness left me.

There was a mirror fixed to the top of the bed (rather like a car's wing mirror) so I could see what was going on in the ward because I was unable to do more than move my head. I would watch in the mirror for the drugs trolley to make its slow progress along the ward to my bed. The drugs administered by mouth were merely a top-up for the morphine injections, which I would request as often as possible. The sweet shots of morphine, wrapping itself around my broken body like a warm blanket, were the only thing to dull the pain. For a few hours, there was blissful release. I would watch the clock on the wall, counting down the minutes until the drug kicked in. But during the time before the next injection, once the pain began to reassert itself, there were terrible moments that seemed to stretch out to infinity.

Every evening after supper, the television would be switched on in the ward, fixed high above the beds on one wall, so that we could keep track of what was going on in the outside world. Many of the patients on the orthopaedic ward spent several months in bed, in one position. The television flashed images before our eyes – of the Winter Olympics, Madonna, and the miners' strike – all segued together in one narcotic haze. I could listen to music on my headphones, but that was all I was capable of doing.

Craig and my family visited me often and one of Craig's colleagues at Release wrote to me regularly (as she did to several prisoners abroad). I held on to life by a thread, neither dead nor alive. It was my first surgical operation. I had no idea how vulnerable it would make me feel, to lose confidence in my body and to know how badly broken it was.

When I returned to the operating theatre for the second part of the operation a week later, I felt completely unprepared to go through another ordeal – I had not yet recovered from the first. This time I was better informed about what the procedure would entail, but perhaps that was worse than not knowing. Both operations had been lengthy, lasting six

to eight hours. When I awoke in the recovery room after the second operation, I felt relieved that it was over, but the last of my strength had drained away and I had no fight left.

Back on the ward after several days in intensive care, the nurses were able to move me on the bed at regular intervals now that my spine was fixed into position – first on to my left side, then on to my back, then on to my right side, and then on to my stomach. I spent six weeks in hospital recovering from the operation. At first, I could not even sit up. I had to re-learn the simplest things: how to wash and dress, comb my hair and manoeuvre my wheelchair. It was like being a child again. The smallest things seemed to require major effort. I spent many hours with the physiotherapist and the occupational therapist towards the end of my hospital stay.

About a week before Easter, I was finally discharged. My mum and stepfather picked me up in their car and I had to shuffle on a transfer board, inch by inch, from my wheelchair to the car seat. The heavy plaster cast I wore impeded my mobility as much as the pain of moving. My arms and shoulders had lost their strength in the three months I had been in hospital. I was very weak and still reliant on heavy painkillers.

After several weeks at home, with a lot of effort on my part in learning to handle day-to-day tasks, and with the healing of time, I was well enough to return to my own flat and live independently again. My freedom was still very much restricted by my poor physical health, but I enjoyed having my own space, a precious commodity denied me in recent months. Gradually my friends found out I was back home and started visiting again. Some friends told me they had called for me while I was away and, when Craig had answered the door and refused to tell them where I was, had thought he must have murdered me and buried me in the back garden – a rather extreme reaction. Other friends merely thought I had been on holiday.

After three months of wearing the plaster cast (which felt like a suit of armour and protected me from the outside world), I went back to the hospital to be fitted with a plastic corset. At least I would be able to remove the corset from time to time to wash myself. It was summer and the plaster cast had become hot and itchy.

Being cut free from the plaster cast was a moment of liberation. A wonderful, jubilant triumph. But without the plaster cast I felt like a turtle without its shell, strangely vulnerable. The plastic corset supported my spine in its new position and was far less heavy and cumbersome than the plaster jacket had been; yet I was still greatly restricted in my mobility.

Now I wanted to try to forget about my recent ordeal in hospital and focus on creativity instead. Fortunately, I was soon able to begin work in my studio at home again and I realised how much I had missed that activity while I had been immobilised. At first, I made small collages using paper and paint, and eventually progressed to using collage on canvas. I could not have tackled the physical demands of painting on a large scale at that stage because I was still unable to move freely and couldn't stretch or bend. It took some time before I was able to resume painting with any confidence, but at least I had made a start.

Apart from time spent with friends at my flat or at home with my family, I hardly went out. My social life was not a priority. I was still recovering from the after-effects of the operation. I wasn't particularly concerned

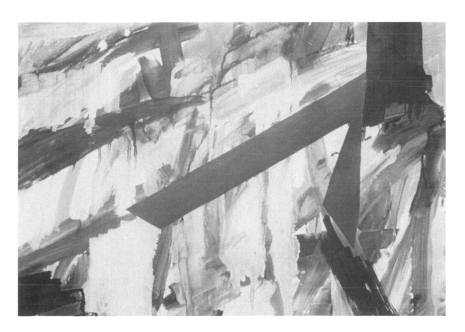

Collage. 1984. Mixed media on paper. 37 x 52 cm

at how small my world had become, I just enjoyed being able to live independently again, away from the hospital. If this was all there was to life, that was fine. Anything else was a bonus.

In the autumn, I was finally free of my orthopaedic corset. The operation had been a complete success, but it had left an indelible mark on my spirit: I knew that I was not invincible, that my body was actually very fragile.

To celebrate the successful outcome of the surgery, along with Craig's 30th birthday, we went to Brixton Academy, a music venue in south London – the first time I'd been out socially for nearly a year. I was not used to being among so many people and Craig pushed my wheelchair through the crowds with the utmost care, as if I were the most delicate of creatures. I was excited to be out in the world again and able to lead a fuller life.

I soon had my life back on track, with plans for the future. I felt better than I had in years, although complete recovery from the operation took some time. I was still coming to terms with the impact the surgery had taken emotionally. It is hard to describe how it feels: everything you have accomplished in the past counts for very little at such a moment. I had plenty of time for reflection during the many days I spent in hospital, lying flat on my back, considering my future and my priorities. I knew that I needed to make a change in my approach if I were ever to move forward in my career. This was something that was still very important to me. I was very aware that I had already wasted too much time.

I decided that in the future I would work part-time at a job so I could have the money to spend on getting a studio outside of my flat – something I thought might also improve my quality of life. The sacrifice I made in studio time would be compensated by an ability to invest financially in my studio practice and it might also be an opportunity to meet other artists. Sometimes the isolation of being an artist is difficult. However, I wondered whether I would have the energy to do both – work at a job and in my studio at the same time.

In February 1985, I found a part-time job teaching art and craft at a day centre for elderly people in Hornsey. Although unsure as to how I would succeed at such a job, I was also quite excited to begin something new.

The day before I was due to start, there was an unexpected visit from my local priest. I had no idea why he should be calling on me. I had once met the priest through the National Council for the Welfare of Prisoners Abroad (NCWPA, the human rights and welfare charity that Craig had recently co-founded, known as just Prisoners Abroad since 2002), but had not given him my address. The priest told me that Craig had been found dead that morning in bed, that he had choked on his own vomit. I was completely stunned. In disbelief – the first thing I said was: 'He can't be. I only saw him three days ago.' But shock is numbing; it takes a while for grief to kick in. When I finally grasped the awful truth of the situation, I was completely devastated.

I got through the next few hours on autopilot, in a kind of daze. I even started my new job at the day centre the next day as planned because I thought it would be something Craig would have wanted me to do. But I soon found that I couldn't function properly and needed time to come to terms with my loss. There were two inquests and a funeral to attend. I left my job after only a few weeks, unable to continue. Craig's death hit me hard.

I went to Craig's funeral and then on to the wake afterwards. I recognised most of the people at the funeral, among them one of Craig's ex-girlfriends, Clare. At the service, Clare stood up and read a poem she had written about him, her voice trembling with emotion. Several of Craig's friends carried his coffin. Craig's sister, whom I had met many times over the years, was there supporting her mother, along with many of Craig's colleagues from Release and the NCWPA. It seemed so unreal.

It was such a sad day and very upsetting. I thought about the unconditional love Craig had given me and knew I would miss him terribly. It seemed such a waste of life to die at the age of 30, but Craig had already accomplished a great deal in that short time. In recognition of his contribution to the charity, founded in 1978 at the onset of the Iran crisis when Release were struggling to get the British out of that country before the revolution took hold, the National Council for the Welfare of Prisoners Abroad named a fund after him, the Craig Feehan Trust, so his

name lives on through his work. Craig was well-loved and remembered with affection by all who knew him.

As I was about to leave the wake, Oliver (a friend from Release) came over to say goodbye. I thought about the last time I'd seen him with Craig: when he had picked us up from my flat in Tottenham one Sunday and driven us over to Finsbury Park, where we'd spent the afternoon. We had sat in my flat that evening, smoking a spliff and watching *Captain Bilko* on the television. It was the last time I ever saw Oliver, that day at the funeral. He died of a heroin overdose soon after. Later, I wondered why it was, that out of all three of us, I was the only one still alive. It didn't seem possible. Surely, if anyone was doomed, it should have been me.

With so much sadness around me, I was even more determined to make a change in my life. There were dark times after Craig's passing. He had been so protective of me. Forced into making a new life for myself without his support, I stopped further contact with many of the people I'd known. I seemed to float from one extreme to the other and couldn't concentrate on my painting, although I tried to. This was unlike me. I can usually work my way through most things, but I distrusted the people around me and there was a nasty undercurrent of violence that surfaced soon after Craig's death.

In the spring of 1985, my flat was broken into and ransacked. A brick was thrown through my window and my door kicked in on a drunken binge by my upstairs neighbour, who also threw a punch at my face and tried to attack me with a hammer. I knew I was very vulnerable and feared for my life. The police cautioned my neighbour, but I did not want to stay there after that.

During the Tottenham riots that summer, I knew several people who were involved in the events at Broadwater Farm. They carried knives and enjoyed the thrill of the riots as much as if it were a football match. I had had enough of Tottenham. It was no longer a safe place for me to live; I was just not tough enough to stay there alone. I moved back home to Walthamstow until I could find somewhere else to live.

But things had also changed at home in the last few years. My mum had recently been diagnosed with a rare connective tissue disease and

had become increasingly debilitated. I saw her condition deteriorate over the years but she had not told her family that she had a terminal illness. She had not wished to share this with us and lived on with remarkable will power for 10 years after the initial diagnosis. Mum bore her illness with fortitude and was so inspiring. I wish I had been able to do more for her, but I was not the kind of daughter who could be much help in a practical sense. I tried to offer some comfort throughout her illness and not to burden her with my own problems.

I had by now been out of art school for six years and my progress up to that point had been painfully slow. This was compounded by recent health problems and I was still coming to terms with the limitations that were part of my condition. Once again, I found that I had nowhere to paint and I missed my studio terribly, so I turned my attention to finding exhibition space for my paintings instead.

My previous group show in 1984, 'Fertile Eye', had been at Brixton Art Gallery in south London, a gallery run by an artists collective. I enjoyed the camaraderie of being part of the collective but, because I didn't live in the area, my contacts there were short-lived. My next solo exhibition was closer to home, at an arts centre in Stratford, east London. This exhibition proved a valuable introduction to the local art scene where I joined a group of artists who were all based in the area. Together we opened a gallery in Walthamstow's Lloyd Park, the Changing Room Gallery, where we showed our work.

I discovered a thriving community of artists in east London, something I had been unaware of when I lived there in the late 1970s. Artists tend to congregate in areas that are ripe for re-development, where rents are cheap and workspace is plentiful. East London at that time was home to many artists although there were still very few galleries in that part of London. The Whitechapel Gallery, a long-established venue, was one of the few galleries in the area showing international artists. The art world at that time radiated from Cork Street in the West End, with several alternative galleries springing up around Portobello Road in west London.

Although I didn't have a studio to work in, 1985 was a productive year. I had a further two solo shows in close succession: one at the Albany

in Deptford, south London, and the other at the Soho Theatre in central London. At the Albany, I exhibited a series of large canvases in one room and hung unframed works on paper in the café (stuck rather haphazardly to the wall with double-sided tape). This rather unprofessional method of hanging the work, of course, had repercussions. The director of the Soho Theatre was having lunch one day in the café, just as one of my works on paper sailed down from the wall and nearly landed on his dinner tray. It could have been a disaster but the director phoned me the next day, inviting me to show my paintings at the theatre, saying that my work deserved a better place to be seen. I was glad my work had attracted his attention, however unconventionally.

It was exciting, taking the paintings straight down from one venue and on to the next. It felt like a touring show. One of my friends arranged an opening party at the theatre with food and drink and we were able to feed many of the starving actors at the private view. Actors, musicians and artists are very alike in that respect – we are always hungry.

I needed to move forward with my life and find somewhere to start painting again – and somewhere of my own to live. Basically, I found myself in the same situation I had been in when I left Falmouth. But this time, seven years later, a studio was not so hard to find. This time, I had a good contact, who was able to help.

A friend I'd met at an evening class introduced me to a group of artists in Claremont Road, Leytonstone, nearby – a community who were living in short-life housing. I was only now realising the value of a peer network. Afterwards, in the local pub, I asked some of the residents if anyone knew of a place where I could paint and someone suggested Markhouse Road School, a disused school in Walthamstow that had been converted into an adult community centre and drop-in centre for the unemployed. I was introduced to the project leader, who gave me a room there, rent free, which I used as a temporary studio over the course of the next year. At least I was able to continue my practice, if not in ideal circumstances, and I was finally able to get my creative life back on track.

I knew that I also needed to finance my practice and buy art materials, so I found a part-time job in Leyton as an office clerk and spent the rest

of the week painting at my studio. I was quite hopeless and inefficient in the office, making mistake after mistake, but it showed me what life was like for so many people who have to deal with office politics on a daily basis: how the most insignificant event becomes the subject of gossip – your choice of clothes, shoes, and even sandwiches. But I learned to be punctual and the importance of having some kind of structure. It was nice to earn a wage, although the work was extremely boring and seemed rather pointless. Fortunately, the contract for the job was only for a year.

After a half-hearted attempt at making a living outside of art that had been rather unsuccessful, I decided instead to concentrate on what I knew best and became a self-employed artist through the Enterprise Allowance Scheme. This was a government-sponsored programme that encouraged people to set up small businesses. Many artists saw this as an opportunity to support their practice and it was a way of becoming more professional about one's work.

Studio portrait. 1987. Markhouse Road School, Walthamstow, London

Therefore, in 1986, armed with a business plan and an overdraft facility of £1,000 from the bank, I registered as a sole trader and took a one-year lease on a studio in Stratford Workshops, Burford Road, near the 2012 Olympic site. The workshops were situated next to a wholesale fruit and vegetable market where the traders came to sell their produce.

Renting a studio outside of my home for the first time made me feel I was at last on my way to becoming a professional artist. My work unit was very small, but it was a good start. My neighbour in the workshop next door was a manufacturer who worked all day at his machine with ruthless efficiency, wearing earplugs to lessen the sound. Another of the small businesses in the building made pub signs, others made leather and suede jackets or ran printing works and catering firms. A diverse group of businesses; but none of the other tenants were fine artists.

I tried hard to master the basics of running a business, though it was quickly apparent that a career in art is often not the most lucrative employment. A friend introduced me to an accountant in Chinatown who was willing to trade one of my paintings for his services. He taught me the rudiments of book-keeping, of which I was entirely ignorant.

I became very attached to my little studio and tried hard to make a success of my first year as a self-employed artist. In 1987, on the night of the hurricane that devastated the country, felling trees, smashing windows and causing electricity outages, my first thoughts were for my studio. Fortunately, no damage was caused to my beloved space. The year 1987 was also an extremely bad year for the financial world. It was the year of the stock market crash – Black Monday. But this had very little effect on me at that early stage in my career.

I am sure I made a loss in the first year. At least there was an overdraft to draw on, and I wasn't particularly surprised. I had lived on virtually nothing before, and would do so again if necessary. I soon realised, however, (with my overdraft facility rapidly diminishing), that I would need to supplement my income if I were ever to break even in my business, so I decided to try selling postcards of my work to increase my turnover. I hoped to cover the cost of my studio rent with this additional income and soon found that, with a little effort, this was indeed possible.

I had print runs made of some of my paintings, and gradually built an impressive client list with established bookshop chains such as Waterstones, Dillons and Blackwells, as well as galleries and independent bookshops. This was hard work but also good publicity, and it is surprising how many people told me later that they had first seen my paintings on postcards. I liked the idea of selling thousands of postcards and not knowing who would buy them or where they would end up. It was a bit like a lottery. Occasionally a card would reach someone who would keep it as an artefact, while other cards would be dispensable and used simply as a means of communication, which was, after all, their purpose. Many years after I'd abandoned the project, a woman contacted me to tell me how much she treasured one of my

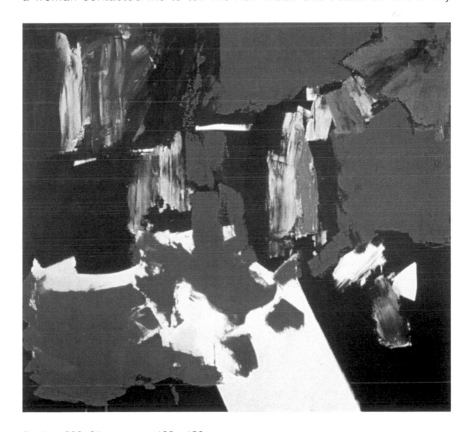

Reality. 1988. Oil on canvas. 135 x 150 cm

postcards that she had bought at the Whitechapel Gallery and how it had moved with her from house to house over the years. Moments like this made all the hard work seem worthwhile.

One thing that really changed my life at that time was learning to drive a car, something I had resisted for years because I was not a natural driver and had absolutely no sense of direction. I found it was fun learning to drive with hand controls. I infuriated my driving instructor by making emergency stops for pigeons and he despaired of my chances of ever becoming a motorist. He refused to allow me to use his car to take the test, so I changed my driving instructor and passed the driving test on my second attempt. I bought a second-hand car, a beige Metro, which at last gave me my independence – life in the fast lane.

In 1986, I moved to Leytonstone near my younger sister, and settled into a new life. I had by then been living at home in Walthamstow for two years and was once again ready for a fresh start. I had a new circle of friends, which included local artists and a group of musicians in south London, some of whom bought my paintings. I was very grateful for their support at such a difficult time.

In addition, one of my friends went to the Whitechapel Gallery to enquire about local exhibition spaces for me, and came away with a list of venues. I didn't even know such a resource existed, but she was far more practical in her approach to finding opportunities. She encouraged me to apply to the newly opened Barbican Centre for an exhibition. I thought I had little chance of success, but shortly after receiving my application, the curator made a studio visit to see my paintings and immediately offered me a solo show. I was absolutely delighted. It was a wonderful opportunity. My exhibition at the Barbican would include a selection of paintings from 1978 to 1988, a survey of work from a decade of paintings. I had just over a year to prepare for it.

Chapter Three | **Ten Years of Painting**

It was good to have a project to work towards. I was self-employed, though earning very little money, so I tried to be organised in my approach to future plans. A further unexpected development was that I was offered another solo show – at the Submarine Gallery in King's Cross at the end of 1988 – just two months before my exhibition at the Barbican.

Suddenly, I started having visitors to my studio who were keen to see my paintings. There were visits from two gallery directors from Cork Street, who came dressed in pin-striped suits, looking rather incongruous in the confines of my small studio: we could hardly get three people into my small space and look at the paintings at the same time. When people came to the studio from central London, they found themselves in a very unfamiliar environment because few gallerists ventured to the East End at that time. I was surprised by the number of gallery directors who came to see my work. It seemed that because I now had two solo shows in London before me within the next year, people were interested. If I had had no exhibition possibilities ahead, they would probably not have come. That is how the art world works.

I'd met the directors from Cork Street one Saturday morning when one of my friends, Sarah, was showing me around the galleries in Mayfair. She was incredulous that I had never visited Cork Street before, which was then the epicentre of the art world. We went methodically from one gallery to the next, down one side of the street and up the other. This was high-business art, the kind I had rarely seen outside of museums, where paintings change hands for enormous sums of money. But her family had been involved in art for generations and it was a world that was very familiar to her. After our gallery visits, Sarah, who had recently passed her driving test, drove me home to east London in her new Honda, neither of

us knowing how to read a road map. It mirrored exactly my own approach to driving and my rather haphazard way of navigating around London.

In November, the first of my two solo shows took place. The Submarine Gallery was situated beneath a shop that sold designer clothes (more in line with Vivienne Westwood than Chanel). The gallery was in a basement with no lift so it was not ideal for a wheelchair user, but I wasn't in a position to turn down a show on the grounds of accessibility. The gallery had had recent success with one of its artists, the street artist Mark Wigan, and enjoyed a reputation as a rather edgy, alternative venue.

Both the shop and the gallery were owned by Mike Quinn, a former art student, and his partner Ingrid. Mike had responded positively to my work when he first visited my studio and was very enthusiastic. He particularly liked the large collages I'd made in Tottenham, which he thought were playful. His press release described my paintings as having 'an almost timeless vitality'. I had a good working relationship with Mike and respected his judgement. I knew I would learn a lot from the show – but whether I sold anything would be another matter. It was certainly not a commercial gallery.

A text from the Ten Commandments was pinned to the gallery wall. These words seemed ironic when seen within such a context. Context is everything: 'Thou shalt not make unto thee any graven image, or any likeness of anything that is in heaven above, or that is in the earth beneath, or that is in the water under the earth: Thou shalt not bow down thyself to them, nor serve them.'

We hung a wide variety of work in the gallery that included collages, canvases and drawings. There was a good crowd at the private view. One of the tutors from my foundation year at Camberwell (which I attended for a short while after leaving Sussex University), as well as the director of the Arts Council Collection, came to see the show. I was pleased to see how well my exhibition was received and the comments in the visitors' book were also encouraging.

However, a tragedy cast a shadow over the exhibition. Exactly a week after the show opened, a fire broke out at King's Cross station, a short distance

from the gallery. Twenty-seven people died and, in its aftermath, everyone's attention was focused on the fire and the chaos it brought to the area.

Although my work attracted a fair amount of interest, Mike was disappointed that nothing sold: he had been so excited by my paintings when he first saw them in my studio. But he chose my work because he liked it rather than because it was commercial and the gallery did not depend on selling artwork to keep afloat. Fortunately, the profit made from the clothes shop subsidised it. In fact, when the van arrived at the gallery to pick up my work after the show, my paintings were returned to me with a gift from Mike: two pairs of silver earrings, which I had admired in the shop. I was also invited to take part in a group show at the Submarine the following year.

In January 1988, only five weeks after my show at the Submarine closed, it was already time for my next solo exhibition. This was the project I had been working towards throughout the previous year.

'Ten Years of Painting' at the Barbican was my most important exhibition so far and was also the most professionally presented. For the first time, there was a technician to help install the paintings, which had previously been hung by my friends and family. My show included two large works on paper I had made at art school in Cornwall, alongside a range of more recent oil paintings, and a series of charcoal and pastel works made in London. Through this exhibition, I was able to identify precise developments, and observe subtle shifts in their progress. It was useful to have that moment of detachment and see my paintings exhibited outside of the studio in an entirely different context. I usually showed my paintings in alternative settings but this exhibition was quite different and very mainstream.

The private view was rather formal within the corporate surroundings of the Barbican. The bar attendant, in her uniform of black and white, dispensed drinks from a table covered by a crisp white linen cloth. The people who came to the private view, perhaps bemused by their surroundings, sipped wine from glasses, talking quietly to each other. My mum came later to see the exhibition, by now relying heavily on a walking stick. I was proud to be able to show her my paintings in a good venue

at last, because she had seen them in far less salubrious surroundings in the past.

This survey of my paintings came at a timely point in my career. I realised just how hard I had worked over those 10 years, and how much time and effort I had invested in my paintings. I sold one big canvas during the show, which felt like a triumph. This taught me that selling work is more often to do with where you show it than what you exhibit. I could have 20 exhibitions in small galleries that few people see, but one exhibition with access to a good audience and the chances of selling paintings are greatly improved. I could only hope that at last I had made a breakthrough. Ten years is a long time to work so hard at a career with such little reward.

Doreen Wilder wrote a review of my show at the Barbican for the *Women Artists Slide Library Journal*. It was the first review I had ever had. Her article commented: 'The initial impact made is through the sensation of colour and the sureness with which the artist handles the organisation of space.' She also noted the use of road names as titles for the paintings: 'the angles, arcs and rectangles appear suggestive of traffic signs or maps', concluding rather dramatically that 'the verve and dash of the paintings made for an exhilarating show'.

The Women Artists Slide Library (later to be known as the *Women's Art Library),* where I registered my work, proved a useful resource. Sheba Press found my work there and commissioned me to provide an image for the cover of the first UK publication of *Talking Back* by bell hooks, a collection of challenging essays about feminist theory and social comment. bell is a black American feminist writer. When the book was published in 1989, bell sent a note to the publishers that read: 'The cover is so absolutely beautiful. It has given me so much pleasure and delight this gray winter evening'.

As a disabled woman, I can certainly identify with some of the issues bell wrote about. Direct and controversial, *Talking Back* reflects on the meaning of the personal being political. We both faced discrimination and had to deal with that in our professional and our personal lives. We both had to learn to 'talk back', something that is often discouraged in polite society.

After two solo exhibitions in close succession, I settled back into my studio at Burford Road for the last few months of my lease. I already had another solo exhibition to prepare for: a show of works on paper at South Hill Park Arts Centre in Berkshire. My career finally seemed to be going in the right direction.

In 1988, I was delighted to win a further award from Greater London Arts Association which enabled me to invest in new brushes and paint, as well as canvas and stretchers. It was wonderful to have the luxury of being able to work with good-quality materials rather than simply with what was affordable. In addition, the director of the Arts Council recommended my work to the curator of an international group show, 'Planète Couleur', which was to take place at the Eiffel Tower in 1989 to celebrate the 200th anniversary of the storming of the Bastille. The second part of the touring show was scheduled for Berlin in 1991. Unfortunately, I was unable to travel to Paris for the first stage of the exhibition but saw the show in Berlin two years later. It was my first international exhibition and was a definite step in the right direction.

August. 1989. Acrylic on paper. 32 x 45 cm

In 1989, after my lease at Stratford Workshops expired, I moved to a large Acme studio complex nearby, converted from a former perfume factory. These studios, at Carpenters Road, Stratford, were only a mile or so from my previous work space. It was the largest studio block in Europe with 140 studios on site and an opportunity to meet and interact with a wide range of artists – I was very excited about joining the group. Several floors of the old factory had been converted and nearly 500 artists worked there between 1985 and 2001, including artists such as Rachel Whiteread, Fiona Rae and Grayson Perry.

At first, I rented one of the starter studios on the ground floor: a large room sub-divided into six. The units were partitioned off from each other, yet still somewhat open plan. My studio had a skylight, while some of the adjoining studios had no natural light at all. I worked there for four years before moving to a bigger studio in the same development when I was finally able to afford more space. The floors were concrete and the walls were bare brick in this

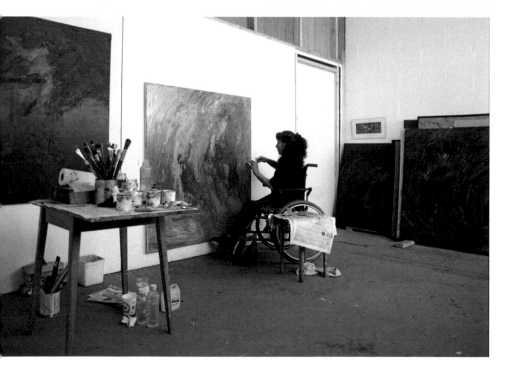

Studio portrait. 1992. Acme studios, Carpenters Road, Stratford, London

neglected, industrial building. The studios were freezing cold in winter, with artists huddled around their calor gas heaters, dressed in many layers of clothing and heavy boots to withstand the chill. An army of mice had invaded the building, infesting the studios and the long dark corridors that connected them. Despite these rather inhospitable surroundings, it was wonderful to be part of a creative environment again and I felt far less isolated as a result, making new friends and seeing other artists at work on a daily basis.

My paintings had changed since my recent exhibition at the Barbican. I was now working in series of six to eight paintings rather than making individual pieces. My working technique had also changed. I often used a palette knife to sweep oil paint across the canvas rather than simply using brushes. At other times, I counterbalanced carefully defined forms against a painterly ground. I was not sure which direction my paintings would take, whether they would be gestural or geometric, but they always remained abstract.

One of the advantages of being part of a studio group was the annual 'open studio' event where artists would welcome the great and the good into their studios. This was particularly useful at the start of an artist's career. The 'open studios' were also an opportunity to explore each other's spaces because we all worked at different times of the day or night and it was quite possible never to meet some of the artists whose studios were in other parts of the building. I saw a huge range of work at Carpenters Road during the time I was there and met many artists at all stages of their careers.

In my studio, I was still working on paper as well as on canvas. I found that works on paper were a more immediate form of expression and were often easier to sell. I had some success in finding buyers for these through the Anna Bornholt Gallery in Mayfair. Also, Jane Hamlyn (who had recently opened Frith Street Gallery in Soho) took some of my work in stock to show her clients. I really started to believe in myself as an artist at that point as I gradually began to find more acceptance for my work. This also fed into my sense of self-esteem (which was just as important). The more exposure I received for my paintings, the closer I came to fulfilling my potential.

However, my family was often a concern, especially with my mum's illness developing rapidly over the last few years. My family life had been dysfunctional from an early age and remained difficult in later life.

Over the next few years, I continued to exhibit as often as I could, to as wide an audience as possible. During the summer of 1989, I had a one-person show at Chat's Palace, an arts centre in Hackney, east London, where *The Guardian* described my paintings in its listing as *'gestural celebrations of colour and energy'*.

My next solo show that year was at Finegold Contemporary Art, in a disused sawmill in Hebden Bridge, Yorkshire. This is one of the few times I have exhibited in a one-person show outside of London. I was very excited about having the opportunity. The gallery owner hung the work and took care of the publicity, the invites and the private view. All I had to do was arrange the transport of the paintings to the gallery and attend the private view.

A friend and I decided to spend the weekend in Yorkshire to make the most of the occasion. I was looking forward to a few days away from my usual routine and it seemed like a holiday. To add to the sense of occasion, the evening before we set off for Yorkshire, I went to a literary event at the local library to hear the author, Colin Thubron, give a talk about his work.

I had first met Colin many years earlier in Sussex when I was at Chailey Heritage School. His mother Eve would visit me there regularly and I would visit her at home. When we first met, Eve arranged to wear a peacock feather in her buttonhole so that I would recognise her. As she walked up and down the row of children, each in our beds, I was too shy to call out to her. Eventually she found me, and that was the beginning of our long friendship. I called her Aunt Eve. She had the imagination of an adult who can just as easily be with children in their fantasy worlds, and I quickly became very fond of her and her family. But I had not seen Colin or Eve for many years. I wrote to Colin in advance to say I would be at the library to hear him talk, and hoped we would have a chance to meet after the event.

Colin had recently published *Among the Russians* to great acclaim. This was his most popular book so far and brought him a new level of

recognition. In his talk, Colin had a confident, relaxed approach and his audience warmed to him immediately. I was impressed by his achievements and enjoyed hearing him speak about his travels, but it seemed rather odd to see him 'perform' as a professional author because I had never seen him in that role before, having known him as a family friend.

Afterwards, we sat in my car long after the library had closed its doors, catching up on all that had happened in the intervening years. I had lost touch with so many people since I started art school. It had been as much as I could do to stay focused on the present. Colin was a great listener, encouraging me to update him on what had happened in my life since we last met, while I was eager to have news of him and his family. Colin told me his mother would be delighted to hear how well I was doing and encouraged me to stay in touch. I wondered if my life really was as successful or glamorous as he seemed to think it was.

The next day, sharing the drive to Yorkshire, I was glad I was not attempting the journey alone. I was hopeless at navigation, even in London. I enjoyed the open space of the countryside, yet the hills and dales presented particular challenges to my abilities, having learned to drive in the city. I couldn't understand why so many motorists beeped at me on the roads as I crawled slowly up the hills, but I guess I would have done the same in London to such a timid motorist.

At the gallery in Hebden Bridge, I showed a selection of screenprints and linocuts, which I had made at a recent printmaking course at the Cass School of Art in London, as well as several large canvases. There was a good turnout at the private view, with a lot of people wanting to meet me. In London, where many exhibitions open on the same night, it is often difficult to persuade people to attend the opening night without the promise of large quantities of free alcohol. Outside of London, though, there is simply less choice and a new exhibition opening locally is quite an event.

The exhibition was favourably reviewed in *The Yorkshire Post* by Mary Sara, its chief arts correspondent, who commented: '*As well as giving uncomplicated pleasure in form, colour and texture, the work is composed of satisfying balances which enable the viewer to read a narrative of pictorial ideas into them*'.

On our journey back to London, my friend and I stopped off at Bradford, on the edge of the Yorkshire Moors, to see the shire horses at the Industrial Museum, which we both loved. I had not been allowed to ride since my spinal operation five years previously and, seeing the horses there, I really wanted to. I'd had to forge a new life since the operation when my health condition became a priority.

In London, I was slowly becoming disillusioned by the idea that quality of work makes for success as an artist. There is also a certain amount of luck needed and good contacts, and having some money behind you is also helpful, along with the ability to network and the ability to use promotional and basic business skills. These skills took me years to learn, but meanwhile it was clear I was not yet able to earn a living through sales of my paintings alone (and sometimes I doubted I ever would).

I knew I had to think of other ways to supplement my income. I finally admitted that I did not have the means to paint full time and accepted that I had no choice but to diversify. Most artists have to take on some kind of employment to support their practice throughout their career. Therefore, I started work as a freelance artist with Shape Arts, an arts organisation who run art workshops for people with special needs. It was a way of using the skills I already had to finance my painting, something that would not be too time-consuming, consisting of just one morning a week during the initial training period. In addition, I would be using my skills to help others.

My first project for Shape was with a more experienced workshop leader who was my mentor for three months. She lived just around the corner from me in Leytonstone, so we took turns to drive to work together in each other's cars. We were based at a day centre in Dagenham for adults with physical disabilities. Liz had already worked there for some time. Her programme of activities included printing, painting and collage. The group also enjoyed visits to the Whitechapel Gallery where there were guided tours and workshops led by the gallery education staff, who were all freelance artists themselves.

Nineteen-ninety was a busy and productive year, although my personal life came to a virtual standstill with all the demands on my time. I took part

in two exhibitions: the first was at the Trocadero in Piccadilly, curated by the gallerist Dominic Berning, which included work by recent graduates from the Slade and Central St Martins. This led to an invitation to show my paintings in an exhibition at the Bridge Gallery, curated by Orlando Campbell (a school friend of Dominic's).

The Bridge Gallery was above a restaurant in Battersea, south London. My show there would be the first in a series of exhibitions featuring an artist within the context of some of his/her major influences. Actually, I felt it was more a matter of fitting the artist to a set of influences than the other way around, but I was just pleased to have my work seen whichever way it worked.

The opening of the exhibition was in mid-July, on a warm summer's evening. Orlando had to carry me up the stairs to the gallery because there wasn't a lift – a little undignified for both of us, but there was simply no other means of access. My cousin Mandy, who often accompanied me to private views, came with me on the opening night, along with two friends, for moral support. We thought the exhibition looked impressive and were sure it would be a success.

I showed a series of six paintings in one room. In the adjoining room were works by Andy Warhol, Kenneth Noland, Allen Jones, Richard Hamilton and Peter Blake. Orlando found a connection in our work through the high-keyed colour of the pop artists, which was also a characteristic of my paintings at that time. I must say that Allen Jones is not one of my favourite artists, and I would never describe him as an influence, but I especially admired the Noland painting given to Orlando as a gift by one of his family, and the Warhol screenprints. I was proud to have my work seen in the company of such distinguished artists.

I hoped the exhibition would be well received, yet despite a lot of praise for my work and the show being well advertised, nothing sold. The exhibition was originally planned for four weeks, but Orlando decided to extend it. I was optimistic that, with more time, he would find buyers for my paintings. That optimism soon changed, however. Shortly after I had agreed to an extension of the show, I received a postcard from Orlando with a photograph of Margaret Thatcher on the front (and

Peter Illic Presents

BLAKE
JONES
HAMILTON
NOLAND
UMERLE
WARHOL

17th July - 18th August

Private View
Tuesday 17th July 1990, 6.00 - 8.00pm

At the BRIDGE GALLERY
74/76 Battersea Bridge Road

Gallery Open: Tuesday - Saturday 10.30am - 5pm
Enquiries to the Bridge Gallery tel: 071 738 0198

Curated by Orlando Campbell and Maria Andreic

I am not sure if it was ironic) saying that he'd heard whispers of an oncoming recession and now was not the right time to continue with his plans for the gallery. I think the opening show at the Bridge Gallery may well have been its last.

I sent a van to pick up my paintings, a little disappointed, but glad to have had the exposure for my work and an opportunity to show my paintings with such famous artists. I was still unknown, however one looked at it. While I knew that an artist could rocket to fame if taken up by a reputable dealer and with a fair amount of hype, neither of those things had happened to me. I had to be prepared to build my career slowly.

The climate was about to change in the mid-1990s with the arrival of Brit Art, which would change people's ideas of what an artist could expect to achieve in terms of financial success and how quickly one could gain recognition. But I still believed that artists should be judged for their art rather than for how much they were worth in financial terms. As to the recession that so many people could see coming – I had nothing to lose.

I was lucky that my work with Shape was keeping me afloat. At the end of my training, I was given a project at Orchard Close in Wanstead, east London, to work with a group of adults living independently in a new scheme called 'Care in the Community'. The members of this group had all been long-term residents of a mental health institution and had enjoyed very little freedom for most of their lives. It was a difficult project, but one that I was happy to tackle. I spent one afternoon a week at the house, offering art workshops to those who wanted to participate. I set up the workshops using Liz's model as a guide. Working with her in Dagenham had been inspiring and had given me the confidence to experiment, but I learned mainly through trial and error.

Because the residents at Orchard Close had significant mental health problems, their needs were quite different from those of the group I'd worked with before. My new group had a short attention span and mood swings that would shift dramatically within the course of a two-hour workshop. At first, some of the projects I set were perhaps a little too

demanding, but I achieved a lot in the short time I spent with them each week. I quickly realised that the most important thing to establish was trust; the participants needed to feel they were in a safe place to explore their creativity.

On one occasion, I took them to the Whitechapel Gallery to see an installation by Christian Boltanski. One part of the installation contained a series of photographic portraits, *Monument (Odessa)*, hung in a darkened room and dimly lit by what looked like Yahrzeit candles. The group had never seen anything quite like it. As part of our workshop in the gallery, we each shone a torch beneath our chins, telling out loud a secret about our lives (I told them I owned a goldfish). Some of the participants had never visited an art gallery in their lives. In this way, art really did expand their horizons, which is exactly what I wanted to achieve.

I also arranged a visit to Hackney City Farm for them, which I thought might be of particular interest to one of the older residents at Orchard Close, who would only draw and paint hens: the strange thing was that at the farm he was completely uninterested in any of the animals or birds. I tried to find out what other things he liked. He told me that he loved the old movie stars of the 1930s, but he would only draw and paint hens, however much I tried to get him to expand his repertoire. It was a challenging project and one that I tried to make a success. It was very important for me to build a relationship with the residents, which in itself took time to establish.

That summer, I was due to go into hospital at the Nuffield Orthopaedic Centre in Oxford for surgery on my legs, so I had to schedule a complete break from my usual activities. I passed my job at Orchard Close to a colleague at Shape who was only too happy to take up where I left off.

The operation at the Nuffield Hospital was quite minor in comparison to the trauma of my recent spinal surgery and did not leave me incapacitated for too long. Both legs were in plaster after the surgery from my waist to my ankles and I had to endure bed rest until the tendons had healed. But I recovered very quickly once I left hospital

and was soon able to resume my life in London. I knew that health problems put me at a distinct disadvantage with my work as a freelance artist. I had to pick myself up quickly from any setbacks or get left behind in the race. Fortunately, I was very resilient.

Soon after leaving hospital, I was invited to attend a week-long conference in Bordeaux as a delegate with two other Shape colleagues. This was an opportunity to refresh my workshop skills and network with others who worked on similar projects. It was a European convention with delegates from several countries who were all involved in community arts - specialising in music, dance, drama and visual art. I came back from France with renewed enthusiasm and an increased belief in what it was possible to achieve through the medium of art and I was able to share many of the new techniques I acquired in future placements.

My next job for Shape was a three-month project in the children's ward at Hammersmith Hospital, west London, where I spent one afternoon a week. So far, each of my client groups had been different and each had brought fresh challenges. I had never worked in a hospital setting before – or with children. For these workshops, I placed a table in the middle of the ward where we worked together and I gave art materials to the children who were in bed so they could join in too. I was trying to encourage the children to make decisions through their art, because they had so little control over what happened to them in the hospital.

We constructed a huge mobile in the middle of the ward. It was made of wire and silver foil, inspired by the kinetic installations I'd seen at the Christian Boltanski exhibition at the Whitechapel Gallery. Other projects included collage and papier maché. I grew very fond of the children, and they were always eager to see me when I came into the ward each week. I found that I grew more confident about my role as a workshop leader with each new project.

I also learned to compartmentalise my life, balancing the work I did for Shape with my studio practice. Once again, I put my personal life on hold. There was just too much to do. I tried to focus completely on my painting when I was in the studio – that was always my priority – and I tried not to think about things that were peripheral to it. In terms of

my career, I cannot say that things had turned out exactly how I would have liked since leaving art school, but at least I was able to continue painting, maintain a studio, and somehow make a living.

Chapter Four | **Moving Forward**

As I had already discovered some years earlier, it was impossible to paint full-time, however much I wanted to. I was already working hard to supplement the small income I made from sales of my paintings and postcards as a self-employed artist. But I still had to find more paid work to cover my overheads. Gallery education seemed a logical extension of my work with Shape Arts and something I thought I might enjoy, so this became my future goal.

My first experience of working in gallery education was with Yinka Shonibare at the Chisenhale Gallery, in Bow, east London, where we worked together on a project. Yinka became an arts officer at Shape after graduating from Goldsmiths College and went on to achieve great success as an international artist. While I had facilitated gallery education projects with Shape groups, I had not been involved in planning or leading workshops in gallery settings. At the Chisenhale, I observed Yinka closely to see how he approached the task.

First, Yinka gave a talk and slide presentation to the group, where he located the paintings and the artist within a historical and philosophical context. Then, he led practical art workshops using the exhibition as a starting point. This was valuable experience for me but I soon discovered that it was not much different from any of the other workshops I'd led before. In fact, it was much easier working within a visual arts environment than having to improvise in other settings.

I was now in a stronger position to apply to galleries to work on their education programmes with this experience behind me. I was delighted to receive a positive response to my application from the Whitechapel Gallery. The three other galleries I applied to (the Hayward, the Barbican and the Royal Academy) also looked promising and put my details on file.

My first job at the Whitechapel Gallery was to give a talk about the Californian painter Richard Diebenkorn, at one of the Sunday afternoon 'sightline' talks, which were usually very well attended. I already knew and admired Diebenkorn's paintings and had always responded to his work, particularly his *Ocean Park* series. I am sure I must have been nervous, but I felt very much at ease in the gallery where I had spent so much time over the years and was not unduly intimidated by the occasion. I just needed to do enough preparation for the talk to build my confidence. I had never spoken in public before but my first experience was surprisingly enjoyable.

As I led the visitors around the exhibition, I focused on my particular interest in Diebenkorn's work, exploring the artist's shift between figuration and abstraction. The audience was enthusiastic, knowledgeable and eager to participate, and afterwards told me how much they had enjoyed my talk. Subsequently, the Whitechapel Gallery invited me to work on a number of other exhibitions for the education department.

My work as a freelance artist continued with Shape and started to gain momentum. I was now involved with several projects in Hackney where we worked as a team, sharing skills. I enjoyed working with the other workshop leaders and some became friends outside of work too. I learned a lot from my colleagues, most of whom had a great deal more experience in community arts than I did.

One of our regular workshops in Hackney was at a day centre for adults with learning difficulties where many of the group seemed to be isolated in worlds of their own and found communication difficult. Our goal was to somehow reach out to them. Joel, one of our students, was autistic, with profound learning difficulties and extremely limited verbal skills, but he was always gentle and well-mannered. His main form of expression was through art, which he loved. He sang hymns as he worked. Joel always drew people – block-like people, delineated with thick black lines.

Another of the young men in our group, George, rarely spoke, but one of the few words he could say was 'paper'. He gathered paper to make artwork and add to his ongoing project, using materials sculpturally without any rules or boundaries. George carried his accumulated work

with him at all times, sticking the paper together with sellotape to form a huge scroll, and fiercely defending his art against anyone who tried to separate him from it.

I continued to work with this group for several years with various colleagues. I liked to think that our workshops opened up a different world to our students and could enrich their lives, but many of them were already creative. They just needed facilitators and the materials to expand their activities.

Perhaps the most challenging of our projects for Shape was at the day centre of the psychiatric unit at Homerton Hospital in Hackney, where we led workshops that incorporated music, movement and art. These workshops were not intended to be remedial in any way; they were not art therapy and were not intended to heal or to raise deep psychological issues. We simply hoped that the group members would be able to escape the pressures they were under through creativity and self-expression. In this situation, we had to be extremely sensitive to the needs of the participants, who were often very fragile.

I was able to fit the work I did for Shape into my regular studio practice because two of the workshops took place in the evening. However, all this left little time for a social life. I found that at certain points in my life, investing a lot of time and energy into one area of my life at the expense of other things proved fruitful, but this certainly did not contribute to a healthy work-life balance. My work was time-consuming and left little energy for anything else. Fortunately, on this occasion, my single-minded approach reaped dividends within a short space of time. I was offered several exhibitions and my paintings developed in new directions as a result.

In 1991, my work was included in five shows where it was seen by a wide audience. The first of these was at a two-person exhibition held in the spring, curated by Tim Eastop at a gallery in Hammersmith, west London. The paintings in this show made use of intense and saturated colour. I met one of my former college friends at the opening. I had last seen him when we graduated from Falmouth when he had given me his copy of the *I Ching* ('The Book of Changes') as a leaving present.

It seemed somehow appropriate that we should meet again further along in our lives. It turned out that he also worked in community arts. I always find it surprising to discover how other people's lives develop from a shared starting point.

The private view of the show was eventful. Halfway through the opening night, we heard a loud crash outside the gallery. A colleague had reversed his van into my car; my car's headlamps were smashed and glass shattered across the road. I left the private view early and drove back to east London without headlights, hoping I would not be stopped by the police.

When I got home, Colin Thubron, who I'd invited to the opening, phoned to say that he had arrived at the gallery soon after I left and, although we didn't meet there, at least he did get to see my paintings for the first time. He thought they looked very different close up than at a distance. It is as if the viewer has to find exactly the right spot to stand, in order to see the work properly. I know that my paintings ask a lot of the viewer, a cursory glance will reveal very little, and I was glad that at least one of my viewers had taken the time to discover this for themselves.

Following this show, I was part of a large group exhibition at Smiths Gallery in Covent Garden. This show was curated by an independent curator who I first met at my studio at Carpenters Road on one of our open days there. More and more artists were now working in the East End in disused factories and warehouses. 'East Meets West' showcased our work in the West End and the show included many artists from my studio.

In the summer of 1991, the second part of 'Planète Couleur' opened in Berlin. This exhibition celebrated the anniversary of the fall of the Berlin Wall and the reunification of Germany, an event that could not have been foreseen when the show was first planned. I travelled to Berlin for the opening of the show with my elder sister, who very conveniently spoke German (I always find it humiliating to be unable to speak the language in a foreign country). We stayed in a hotel near East Berlin, where we could not help but feel the ghost of what was once in the city, its history etched upon every inch of the landscape. In the hotel bar on our first night, we were told what a special time it was to be in Berlin: the

city had just been chosen to replace Bonn as the capital of the Federal Republic of Germany.

The exhibition took place in a municipal building in Wedding, a vibrant district and artists' community. The opening event was an official occasion with local dignitaries giving speeches at a formal press conference, followed by dinner at a nearby restaurant for the organisers and the artists.

After the launch was complete, we were free to explore Berlin. We took a guided coach trip around the city and the newly opened East Berlin. Our tour guide spoke in German so I could not follow the commentary, but I thoroughly enjoyed it nonetheless.

We also visited some of Berlin's museums and galleries: the Nationale Galerie, the Bauhaus-Archiv Museum and the Martin-Gropius-Bau, where the 'Metropolis' international art exhibition was on show. There, I saw several of Gerhard Richter's big abstract paintings for the first time. Of course I knew of Richter's reputation as an artist, but I was completely overwhelmed by the visual impact of his paintings. It was a very immediate and visceral response, almost like an epiphany. I saw his paintings from across the gallery and was instantly transfixed by the work: at first, I had not even known who had painted them. A wonderful and very memorable discovery.

At night in Berlin, we enjoyed the bohemian cafés and clubs of Kreuzberg, and I was surprised how welcome everyone made us feel. I did not think I would enjoy Germany so much, but five days was far too short a visit and I would have liked to have spent more time there.

When I got back to London, the journey to Berlin seemed to trigger an intense phase of activity in my studio and a shift in the direction of my work. As a result, my paintings became more rigorous and less emotionally charged. I always feel that those few days in Berlin changed my perception, but I'm not sure why. Of course, it is difficult to know exactly when a change in one's work begins. In any case, from 1991 onwards, my work took a different direction, towards a more process-orientated kind of painting. I started to use large planes of colour, often monochrome, and to explore surface and texture rather than form. It was an exciting development in my practice.

Towards the end of the year, I showed my work in a further two exhibitions in London: one was a solo show of paintings and the other a group show. My solo exhibition at the Posk Gallery (situated in the Polish Social and Cultural Centre) in Hammersmith, was an opportunity for me to acknowledge my cultural heritage and family roots.

I am American by birth, but I am also part British and part Polish. My father's history as an eastern European is like so many others of his generation. Originating from Skępe, a small village in rural Poland, he was only 16 when the Germans invaded, requisitioning the family farm. He fled to the surrounding countryside where he fought with the resistance for almost a year before leaving to fight with the Polish Army in France and northern Italy. He arrived in Britain after the war as a displaced person, and it was there that he met my mother. It was in Hammersmith that my parents started married life together, among a close community of Polish friends.

The paintings in my exhibition at the Posk Gallery were described in *The Independent* and *The Guardian* as 'fevered' and 'increasingly painterly abstraction'. However, these paintings were the culmination of a particular body of work. In my studio I was already beginning to develop work that was far removed from 'fevered' or 'painterly' – and much more controlled.

In recent years, I had exhibited extensively and won two awards from the Greater London Arts Association, but I still felt rather disheartened by my lack of progress. It seemed that I was forever destined to remain at the margins rather than in the mainstream with my work. However, the early 1990s was a time of recession. I had already weathered a couple of economic downturns and knew how difficult life can be at such times: the arts are usually the first to suffer and artists particularly so.

Although I enjoyed working as a freelance artist in gallery education and community workshops, it seemed my desire to paint full-time in my studio and support myself through my work was just not possible. In fact, it felt like it might even prove an unattainable goal. When I first started exhibiting, I wasn't at all surprised that my work didn't sell easily, but the struggle to earn a living as an artist continued beyond those early years and did not seem to be changing.

After a busy and productive year, I spent the New Year in Cornwall with friends who had rented a converted chapel near Land's End for the holiday. It was the first time I had returned to Cornwall since 1978. I travelled to Penzance the day after Boxing Day, remembering the many other long train journeys I had taken from London to Cornwall in the past.

The first evening in Cornwall, we ate at a fine restaurant in Padstow and over dinner we planned how to spend the rest of our time. The weather was mild, as Cornish winters often are. Over the next few days we met up with others I had known when I had been living as a student in Falmouth, which reminded me of how different my life had been back then, but I had no wish to be nostalgic about the past.

On New Year's Eve, we visited the tiny fishing village of Mousehole, where a fancy dress parade wound its way through the narrow streets. Most of the children and many of the adults were in costume. Mousehole is one of the most beautiful and atmospheric of the fishing villages on the south coast, renowned for its Christmas lights, which people come from miles around to see. There is a beach and harbour, and stories of smugglers in the cove. We celebrated the arrival of New Year at one of the local pubs, where a group of rowdy rugby supporters, completely inebriated, were chanting rugby songs. Suddenly it was 1992.

On New Year's Day, we drove to The Lizard on the southwest tip of Cornwall. The weather was surprisingly warm and there had even been barbecues on the beach the night before. Somehow, we managed to get my wheelchair down the steep cliff path to the shore (with the help of one of the locals). I collected pebbles from the beach that day and, when I got back to London, put them in a bell jar. The journey to Cornwall had reawakened memories of a past that I thought had long gone.

The new year brought fresh challenges. In 1992, I was invited to be part of a documentary called *Face of our Fear*, which was shown on Channel 4 as part of a disability season. It traced the evolving image of disability through 2,000 years of western culture using film clips, literary quotations and pictorial records. I was quite nervous about being filmed, having no experience nor any desire to perform. I had been in the school nativity play as a child, but that was the sum of my acting experience.

The documentary was made by Stephen Dwoskin, co-founder of the London Film Co-op and a well-respected American experimental filmmaker. His work has been compared to Andy Warhol's because of his camera technique. Dwoskin's camera records as an observer rather than being centred on narrative. His films are often about the process of watching or being watched. Steve contracted polio as a child and comments about disability from a personal perspective:

'It's about the notion of stigma. I think disability carries within it all the prejudice, not just about disability, but all prejudice about race and religion. It all comes out when people are confronted with disability issues. The notion of stigma comes from the tattoo mark that puts someone into the slave class. Anything that appears to be different is stigmatised.'

Indeed, I have often recognised a deep-seated prejudice in people's attitudes towards disability, which may in fact be fear, but I do not think of disability as the biggest part of my identity. I have always thought, rather, that my identity comes from being an artist.

I had a very small part in the film and fortunately there were no lines to learn. There were one or two moments of scrutiny during filming that made me a little uncomfortable: a close-up in the opening sequence and individual portraits of each cast member later in the film where Steve aimed a hand-held camera in our direction and we just stared silently back, returning his gaze. At one point, Steve asked me to read aloud from a book about disability compensation rates – this was simple enough and the scene was shot in one take. I felt rather self-conscious in front of the camera but it was a memorable experience and one that I am extremely proud to have been part of.

Later that year, I had a solo exhibition at XO Gallery in Draycott Avenue, Chelsea. The name of the gallery referred to the French word *expo*. It was my only exhibition that year, apart from an open studio event at Carpenters Road. I showed 16 paintings at the gallery, new work I had made over the last year including *Maybe, Disintegration, Slate, Burnished* and *Red Mirror*, as well as several smaller, acrylic and charcoal works on paper.

There were two reviews of my show and each made reference to astronomy and cosmic imagery. The review for *DAM* referred to the

issn 0961-7485

winter issue 1992 volume 2 no.4 £3.00

"Bridge" Julie Umerle

illusion of depth in my paintings as something 'which allowed one to travel back and forth through time and space, almost like time travel', describing *Slate,* as 'a wide expanse of blue with a strip of orange, suggestive of the trail left behind through an infinite cosmic journey'. *What's On in London* described one of my charcoal works on paper as 'a curiously attractive phosphorescent planet surrounded by an inky milk ring', concluding that my paintings were 'inspired and powerful works and a lesson indeed for those who feel that abstract art is mere geometric flotsam and jetsam'. I was delighted that both reviews were so positive.

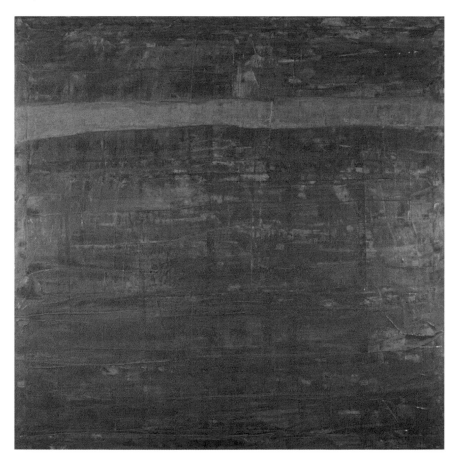

Slate. 1992. Oil on canvas. 127 x 127 cm

My paintings had developed considerably since my last solo exhibition at the Posk Gallery a year earlier, but such progress was the result of many hours spent in the studio. Long ago, I had set out on a path of discovery that involved many circuitous routes along the way. I now felt that, having discarded a lot of these ideas and influences, I was finally able to develop my own way of working. In particular, *Pearl,* a new series of three oil paintings in shimmering white/grey, seemed to mark a turning point in my work. It was as if, by discarding colour, I was finally able to refocus my intent.

In 1993, the director of XO Gallery installed a group show of work at L'Escargot, a French restaurant in Soho much frequented by the media, where she included one of my large oil paintings. It was certainly an improvement on the last time I had shown my work in a dining room at the Albany, Deptford, in 1985.

My mum, meanwhile, spent increasingly longer periods of time in hospital. She was treated with steroids and chemotherapy, but both had debilitating side effects. Her condition deteriorated rapidly and nothing could be done to arrest her disease. She was in constant pain. I grew to admire Mum's strength of character more and more as time went on, her indomitable spirit and the way that she carried herself with such dignity in the face of unbeatable odds. It was heart breaking to watch her decline.

As usual, in the face of personal problems, I continued to bury myself in my work. It was one way of dealing with things over which we have no control. I would have liked to have achieved a more balanced lifestyle, one that did not completely revolve around my practice as an artist, but it never seemed that easy. There's something obsessive about painting, even outside of the studio. I always wished I could be a better painter, and the only way I knew how to do that was to spend more time painting. I know that recognition doesn't come from working in your studio and hoping to be discovered by a rich collector or art gallery. It has more to do with who sees the paintings when they are out in the world and where they are shown. Indeed, artists have to be very determined to succeed because the odds are quite firmly stacked against them.

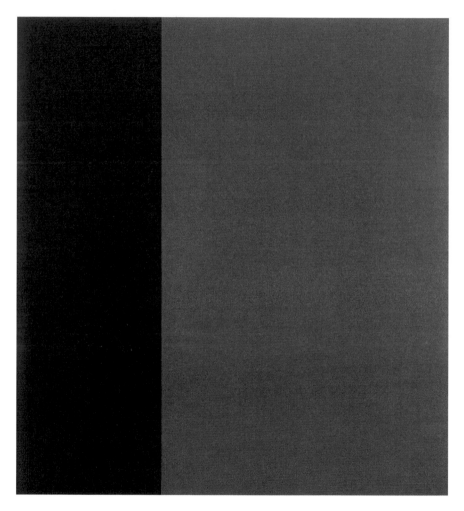

Paragon. 1993. Oil, beeswax and quartz sand on canvas. 150 x 135 cm

Chapter Five | **Gallery Education**

My busy schedule continued at a fair pace as I began to extend the range of galleries where I worked. So far, I had given just one talk at the Whitechapel Gallery and one workshop at the Chisenhale Gallery. To find employment as a freelance artist in gallery education is competitive and artists who do so are often booked time and time again. It is a difficult field to break into. I was already on the database of several London galleries so I was delighted when, in 1993, the Hayward gave me an opportunity to work with them, inviting me to give two talks to the public about the very popular Georgia O'Keeffe exhibition.

This time, I was far more nervous than I had been before. I felt that I needed to prove myself. Therefore, I put a lot of time into my preparation by reading the exhibition catalogue several times as well as a biography of O'Keeffe (*Becoming O'Keeffe* by Sarah Whitaker Peters). Although the talks were basically about an artist's response to the exhibition and did not have to follow a prescribed line, I thought it important to give some context to the paintings. As with my first talk at the Whitechapel Gallery, I visited the Hayward many times in preparation.

I already knew of O'Keeffe's paintings of skulls and bones, I knew of her flower paintings and her paintings of city views. Through her retrospective, I discovered her abstractions, desert landscapes, shells and other natural forms. In my talks, I discussed all these themes in relation to each other and was able to add something about the artist's personal life too. I knew that the audience likes to hear anecdotes about an artist's life: there were always questions about that.

I particularly liked O'Keeffe's comments about her flower paintings: 'Nobody sees a flower – really – it is so small – we haven't time – and to see takes time like to have a friend takes time'.

I was definitely nervous on the afternoon of my first talk when introduced to the audience. I felt a little self-conscious and overwhelmed by the occasion and heard my voice tremble as I started to speak. But the audience was sympathetic and interested in what I had to say and, by the time I reached the second painting, I had regained my composure and everything was fine. I found that the audience doesn't particularly care how you look, but it does care about what you have to say. Assuming an authoritative air actually makes you appear more knowledgeable, so I tried to convey this. Conversely, to admit your nervousness to an audience can be endearing and people will often then support you and will you to do well. I never thought I could succeed at public speaking but the positive response I received from the audience was enough to convince me I had done well.

I continued to work on the education programme at the Hayward on various shows throughout the next few years. Sometimes at weekends, when the gallery was crowded with visitors, people would stand on the banquettes to see and hear the speaker. This was always a little alarming and sometimes I had moments of panic if I stopped to think about the situation, which I tried not to. It was only in retrospect that I realised how difficult it had been.

Another practical concern for me was learning to steer the audience members around the exhibition without losing contact with them. The ground floor of the Hayward is on two levels, accessed by a steep ramp or a flight of stairs, and there is an upper gallery too, so I had to plan my route around the show well in advance. It would be unrealistic for everyone to accompany me up the ramp when it was far easier for them to use the stairs – and, of course, it was impossible for us all to use the lift to the upper gallery at the same time – so I would arrange for us to regroup in front of a specific painting. Most people who joined the talk at the beginning would stay to the end, even if our routes diverged slightly along the way.

I always put far more preparation into each project than perhaps was justified, but this was also a learning process for me and an education in itself. I had a unique opportunity to get up close to the work at times when the gallery was closed to the public and I could spend long periods of time

alone with the paintings, which I really appreciated. As a result, I learned to use language to describe vision and became much more articulate about my own practice. During the talks, I was able to observe how viewers respond to a work of art and became aware of the many factors that determine how the work is perceived.

At the Hayward Gallery, one of the perks of the job was being invited to the private views and having a free pass to the exhibitions. The private view of James Turrell's show, on midsummer's day in 1993, was perhaps the most memorable. Turrell is an American installation artist, who works with light and space – an artist I had long admired. One of his installations was on the roof of the Hayward, where we watched a section of the sky above us framed through a rectangular space cut from a newly constructed ceiling. As the light changed or a plane or bird flew across the space, the skyscape within the delineated area changed. On the night of the private view, we watched the sky change almost imperceptibly as dusk fell on a magical evening.

There were also opportunities to network through gallery education work, which was useful, and I met several artists that way, through colleagues, or at private views. This opened up my life a little more than simply working full-time in the studio, which can be a very intense and isolating experience.

Another of the exhibitions I worked on that year was Lucian Freud's show at the Whitechapel Gallery, where we ran workshops for local schools. With school groups, the artists always hope the paintings will provoke a reaction and our task was to stimulate and encourage that. We wanted to instil an enthusiasm for looking, discussion and art-making in the workshop participants. One of the most controversial paintings in the Freud exhibition was *Painter Working, Reflection 1993,* a nude self-portrait painted at the age of 71. This painting was described as 'a work in progress', the paint still fresh on the canvas when it was delivered to the gallery. It never failed to provoke a response from the children.

Leading the group around the exhibition, we wanted the children to notice the painterliness of the works and the fleshiness of the models and we tried to illustrate the difference between flesh and skin by pinching the skin on

our arms between thumb and forefinger. Viewing the paintings, many of the children thought Freud's studio, depicted in the background of many of his works, looked drab, with its paint daubed walls, old bed, piles of paint rags and dirty sheets. But they were interested to see an artist's working environment, something very few people outside the art world encounter. Although gallery education was, for me, a means to an end – a way to support my practice – I found that it was also stimulating and often fun.

That summer, I moved studios at Carpenters Road – Into one that was twice the size of my starter studio. My new studio was right next door, in the same complex. It was divided into three areas, comprising two working studios and a section of storage racks. At one end was my neighbour's studio; my studio was in the middle; and the storage racks were at the other end. A partition divided our spaces but went only part of the way across. We also had our own sink there, which was a big improvement on the communal sink where I used to wash my brushes before, at the end of a long, dark corridor.

Usually, moving studios is a big procedure, requiring a removal van and a lot of time spent packing paintings. This time, because I only had to move my paintings next door, it was far simpler. In my new studio, it was wonderful to have some quiet moments alone with my paintings. My neighbour Yvonne was often teaching in Newcastle, which meant I sometimes had the studio to myself for days at a time – a real luxury.

There was no doubt in my mind that the separation between studio and home life had proved beneficial. My paintings were already going through a transition. Now, things moved forward rather more quickly. I started to divide the canvas into two planes, using different materials and ways of working to distinguish the two. I still used oil paint, but occasionally added quartz sand for texture, or different painting mediums to change the appearance and consistency of the paint. The contrast between surface and texture became central to my paintings.

In September, Yvonne left London to take up a residency in Hong Kong. While she was away, she sub-let her studio to one of her students who had just graduated from Cheltenham School of Art. Anne Hardy later went on to the Royal College to study photography but, at that time, she was strictly a

painter. She made huge surrealist paintings. Anne worked regularly in the studio and we got used to seeing each other at our practice and learned to be oblivious to each other when we were painting.

That autumn, I was one of the artists working on the education programme at the Royal Academy's blockbuster show, 'American Art in the 20th Century'. This was an overview of American painting and sculpture that began with artists such as Marsden Hartley and continued through to the Abstract Expressionists, Pop Art, Minimalism, and beyond. It was a wonderful opportunity to view many of the paintings I had previously seen only in reproduction – for example, Jackson Pollock's *Mural,* a painting that had rarely travelled outside the United States. The exhibition was like a cross-section of the Museum of Modern Art in New York (which I had always longed to visit) and included many of my favourite artists in one show. It was full of treasures.

The Royal Academy blockbuster shows are always packed, with lines of people waiting in the courtyard outside and queues for tickets. Once inside the galleries, it is often difficult to actually see the art because of the vast crowds. As part of the education team, I was able to see the show before it opened to the public, which was a real bonus.

My work involved leading talks and discussions with the many groups who visited the Royal Academy. I especially enjoyed the planning sessions in the galleries with the other artist educators who were working on the show, where we discussed the exhibition in great detail and each brought a unique perspective to the show.

Our talks were booked frequently throughout the course of the exhibition and for private events in the evening, with the exhibition's sponsors as well as other corporate visitors. In the evening, we would wear tags identifying us as RA education staff so that people attending the event could approach us informally with questions.

During one of these events in the gallery, a Merrill Lynch banker asked what he should think in front of a Rothko painting. When asked what it was that he saw, he replied that he saw nothing – which in itself was revealing.

Earlier that year I visited an exhibition of Robert Ryman's paintings at the Tate, an artist whose work has been a big influence on my own. Ryman

is one of my favourite American painters. His work taught me that paintings don't need to be emotional to be powerful and they don't need to be large to be effective: many of his paintings are domestic sized. I loved the quiet restraint of Ryman's work, using mostly just white paint. When I was in New York three years later, I met Robert Ryman. I fell in love with his paintings at that exhibition at the Tate.

In November, I was invited to give talks at the Hayward Gallery about a show by Roger Hilton. This time, the exhibition was on the ground floor only. With fewer paintings, it was possible to talk in greater detail about each piece of work. Hilton was someone I was keen to know more about because of his links with Cornwall.

Hilton had lived on Botallack Moor, near St Just, in the mid-1960s, and he had spent a great deal of time in Cornwall over the years. His paintings, at first influenced by Mondrian, were built around the relationship of form to format and surrounding space. Hilton had studied in Paris as well as in London, where his work shifted between abstraction and figuration. This was my area of particular interest in his work, and something I tried to highlight in my talks.

One of the strongest paintings of the exhibition, I thought, was a striking self-portrait made towards the end of his life, which spoke volumes about the man. The show concluded with a series of rather delicate gouaches made shortly before his death. In many ways, this show complemented the 'American Art' exhibition at the Royal Academy that I was working on at the same time, looking at a British abstract artist through the context of American abstract painting.

At the end of the year, I was invited to a Christmas staff party at the Royal Academy, where tables were laid out in the gallery to host a spectacular feast. First there were drinks and music, then we ate at the tables surrounded by masterpieces on the walls, and finally there was entertainment provided by some of the staff in fancy dress (including the curator Norman Rosenthal). It was fun to see such people in unguarded moments and a lovely remembrance of my experience of working there. The evening was very relaxed and not at all intimidating, bringing 1993 to an end on a good note.

Looking back on that year, I realised I had solved one of my major problems: I had developed several ways of financing my studio practice. I was selling postcards of my paintings (and these continued to be a source of income that usually covered the cost of my art materials); I continued working on community arts workshops with Shape; and I began to build a reputation as a freelancer within the gallery education circuit. Indeed, I needed all these means to survive because sales of my work were still slow.

I learned from other artists in my studio that another way to generate income through sales was by working with an art consultancy. My first experience of selling works in this way was through a consultant who found slides of my paintings at the Women Artists Slide Library and sold four pieces of work to her client. By chance, I met her again at the Chelsea Physic Garden the next summer, at a private view for the 'Natural Settings' show. I had never visited the Physic Garden before, a secret garden tucked away behind a brick wall near Chelsea Embankment, with borders of herbs, shrubs, medicinal and aromatic plants, at its very best on a warm summer's evening. I went to the private view with Anne Hardy and enjoyed discovering the artwork installed in trees, bushes, glasshouses and the most unexpected places, where it was often difficult to distinguish the exhibit from its environment.

Meeting the consultant there was fortuitous. For an artist, the perfect introduction to a gallery is through someone who already knows your work, because it is difficult to approach a gallery without a recommendation. She told me her brother had recently opened a gallery in Walton Street, Chelsea, and that she would tell him about my work. She encouraged me to send him slides of my paintings. The introduction was successful, followed by a studio visit, and I later showed my work in two group shows at the Blue Gallery.

I continued to make steady progress in my studio practice. In my new series of paintings, *Paragon*, I used the principles of the Golden Section to decide the proportions and divided the canvas by colour or by contrasting surfaces. The paintings were monochrome, in muted rather than high-keyed colours. The surface of one side of the paintings contrasted with the other, using various materials such as high gloss varnishes, quartz sand or beeswax to change the consistency of the paint.

My next series of paintings, *Flock*, developed this format by countering an opaque area of paint with an area of mark-making. Gradually, I began to move away from oils and, for the first time in years, began to use water-based paint (acrylic and watercolour) on canvas. Often, I would use pigments and binder to make the acrylics myself because the pigments gave a purity and intensity to the colour that can be lost in manufactured paint.

With these two series of paintings, *Flock* and *Paragon* (each measuring 152 x 137 centimetres), I found a way forward that had previously been closed. I realised that a change in my working environment and time spent outside of the studio had changed the direction of my work and opened up new possibilities. My work had developed accordingly.

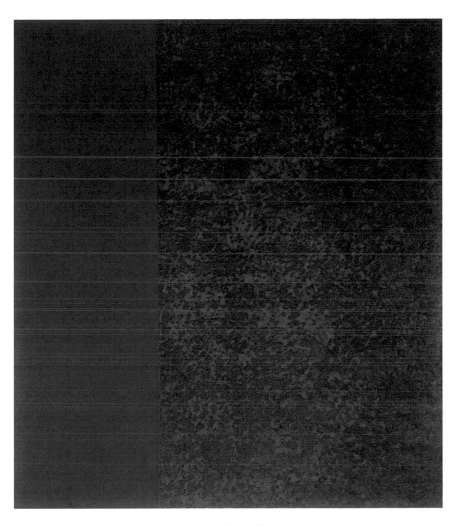

Flock. 1994. Oil and quartz sand on canvas. 150 x 135 cm

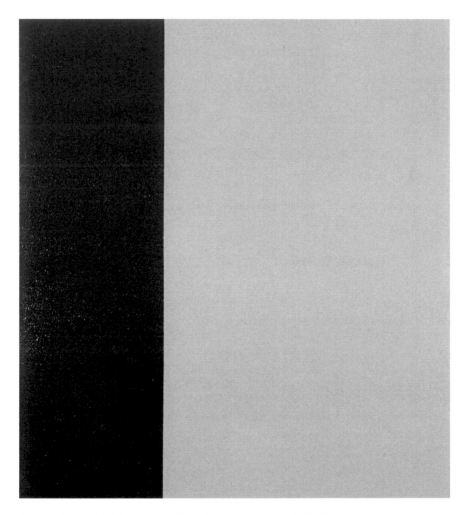

Paragon II. 1993. Oil, beeswax and quartz sand on canvas. 150 x 135 cm

Chapter Six | **Into the Light**

However, away from my working life, there were family problems. In April 1994, Mum was admitted to the Royal London Hospital in Whitechapel for a surgical procedure on her ulcerated leg. The operation was unsuccessful; the infection continued to fester and complications set in. Her organs began to shut down. First her heart gave way and she was fitted with a pacemaker, and then her kidneys stopped functioning.

My family and I kept watch at her bedside as she lapsed into unconsciousness. My mother did not want to live if it meant being on life support, so, according to her 'living will', further medical interventions to keep her alive were terminated. Her pacemaker was disengaged and intravenous methods of nutrition and hydration discontinued. Mum was sedated by diamorphine, which would sometimes induce the most awful body tremors, where her eyes would shoot open and she would stare straight ahead. I wasn't sure if she was aware of our presence, but we kept talking to her anyway and she would squeeze our hands, which made it seem that she was. We felt completely helpless as we watched her condition deteriorate towards the inevitable conclusion.

My sister and I were at her side on the morning of 30 April when she died. She passed very peacefully, although the lead-up to her death in the previous weeks had been harrowing, particularly through the last few days when her breathing became shallow. At the moment of her death, it was as though her essence left her body and all that remained was a shell. I suppose that when a person is chronically ill and in pain, death is seen as a merciful release, but my family felt she had gone before her time. It was difficult to bear. Mum took with her so much of our pasts. I was heartbroken.

My family wondered what would have happened, and what kind of future Mum would have had, had she chosen to seek intervention to remain alive. But her wishes were clear and we had to respect them. Mum knew she would have needed to have her leg amputated, to undergo dialysis and to use a pacemaker for the rest of her life, had she wished to live. But she didn't want to live that way with what she considered an unacceptable quality of life. Besides, it would only have delayed the inevitable and she could not deal with the unrelenting pain of her condition, which would not have abated. I don't think she could have survived further surgery and it would have been unkind to ask that of her.

I was back in the studio within a matter of days. I didn't want to stay at home and continue to relive what I had just witnessed, or dwell on the grief of what might have been. Nevertheless, the grieving process (as I already knew) takes a long time to get through.

I continued to work hard at my painting. I had a solo exhibition to prepare for the following year that was already taking up a lot of my time. I had workshops to run for Shape and an open studio weekend fast approaching. By focusing on my painting and keeping busy, I felt more able to move forward from my recent loss.

The annual open studio event in mid-June was the last one I participated in at Carpenters Road. I invited Colin Thubron to the exhibition, although I had not seen him for five years. It was strangely comforting to see him again, someone from a very distant past. Since we had last met, he too had lost a parent – his father Gerald. I knew that he and his mother must have missed Gerald terribly. Again, Colin told me that his mother Eve would be very happy to hear from me and assured me that I just needed to pick up the phone or drop her a note to arrange a visit. I thought it would be difficult to make up for so much lost time, but eventually I did contact her.

Eve still lived in the same house in Sussex I had visited as a child, and we resumed our friendship as though we had never parted. I was very glad that I had been able to see her again towards the end of her life, because she had played such an important part in my childhood. Our feelings of affection for each other remained the same despite the long absence.

My only other exhibition that year was at a group show in central London – a pop-up in an empty shop. I had three recent paintings in the show. The private view was exciting, it was well attended and we even had champagne. Lots of people came to the opening – fellow artists from my studio and colleagues from work. It was an opportunity to reach a large audience and to see my paintings in a new context.

Meanwhile, I was preparing for my solo exhibition, at the Herbert Art Gallery in Coventry. I had a new series of paintings to complete for the show and also needed to find a sponsor for the catalogue (which was largely funded by Coventry City Council). Rebecca Fortnum, who was then a lecturer at Winchester School of Art and knew my work through the Women Artists Slide Library, agreed to write an essay for the catalogue. This would be the first publication of my work, so it was an important project for me.

Eventually, after a long and difficult search for funding, I was supported by Alan Fitzpatrick, the owner of the shop where I bought many of my art materials. Alan had first seen my paintings in one of the open studios at Carpenters Road and had introduced me to Lascaux paints, a range of high-quality artist materials, at his shop. Upgrading to better quality paints immediately brought a new dimension to my work. We would often hold long discussions about art materials when I visited his shop – about the materiality of paint and how the materials were behaving, an important part of process-led work. I was delighted to have Alan's support for my project.

In 1994, I worked on three gallery education programmes: the Franz Kline show at the Whitechapel Gallery; the Pierre Bonnard show at the Hayward; and 'A Bitter Truth: Avant-Garde Art and the Great War' at the Barbican.

The Franz Kline show was held in the spring. Having recently seen several of his paintings in the 'American Art' show at the Royal Academy, I knew this period of art very well and had always admired his work. For this exhibition, I worked with an Indian dancer Shobna Gulati (who later became a household name as a television actress) on the educational programme. We devised a workshop to accompany the exhibition combining dance, movement and painting.

An Abstract Expressionist, Kline's paintings are about gesture and vigorous brushwork; Shobna was able to find ways to interpret his paintings through Indian dance moves. One of the most successful of the workshops was the one we ran for the gallery staff (including the director, Catherine Lampert), who all kicked off their shoes to take part.

In August, I worked on the Pierre Bonnard show at the Hayward. Looking at his paintings was like decoding a puzzle with most of the activity occurring on the outer edges of the canvases, where his subjects are almost hidden among a wealth of details and a flurry of brush marks. Bonnard's relationship with his wife, Marthe, was also intriguing, as revealed through the many domestic details of his paintings. The colours and textures of the landscape, together with the intense Mediterranean light depicted in paintings such as *The Riviera* (1923), provided a glimpse into his world. It was a pleasure to help others make this discovery too.

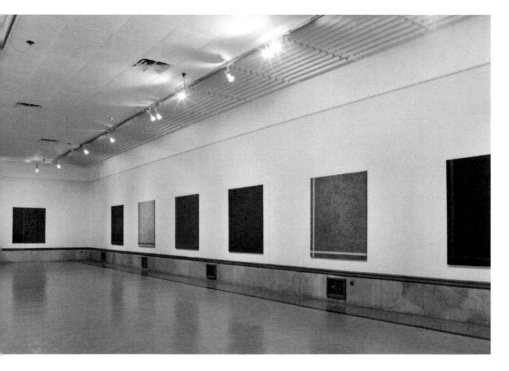

Installation View of 'Recent Paintings'. 1995. Herbert Art Gallery and Museum, Coventry

In November, I worked on the educational programme at the Barbican Art Gallery for the first time. Of course, the Barbican held a special place in my affections because it had been the venue of my solo show in 1988. This exhibition was a survey of artists who made work about war and the futility of war. One of the highlights was Käthe Kollwitz's woodcuts and bronzes. Two of her sculptures in particular, *The Tower of Mothers* (1937-38) and *Pietà* (1937), were highly charged, evoking a strong emotional response from the audience.

Meanwhile the contemporary art scene in London was buzzing as a result of the rise of Brit Art. In 1988, Damien Hirst had kickstarted the movement with his curation of 'Freeze', the exhibition that brought him and his fellow Goldsmiths students to prominence. I remember seeing a flyer for the show posted in the corridors of Carpenters Road studios soon after I first moved in.

The 1990s were dominated by the conceptual art of the Brit Artists, who soon become the new establishment. Although I appreciated the work of some of the painters – Chris Ofili, Fiona Rae and Peter Doig in particular – I had no appetite for the posturing of many of the artists, nor for the self-revelation in their work. Once again, I felt very out of step with contemporary painting and decided this would be a good point in my career to refresh my practice. I also wanted to spend some time outside the UK.

In 1995, I applied for a place on an MA course at Winchester School of Art, a European-based course that entailed a period of study in Barcelona as well as in Winchester. I was invited to attend for an interview but wasn't offered a place. After the interview, I was told the reason for this was that the school's base in Barcelona was in the old town, near the Museu Picasso, and the cobbled streets there would be too difficult for a wheelchair user to negotiate. Also, the classroom was at the top of a flight of stairs and there wasn't a lift.

It seemed so unfair. I was upset and angry at being rejected for reasons other than my artistic abilities. Frustrated that I was not able to do anything to address the problem, I made an official complaint. However, all my old insecurities came back to haunt me – about how difficult it is for a disabled

person to compete on equal terms within the art world because of the many external factors that play a part. Of course, it might well be that I just wasn't talented enough to compete. For a disabled person to be part of the mainstream, it is often not enough to be talented, you have to be exceptional. I have never claimed to be a genius, but then so few artists actually are geniuses. Recognition comes from other factors. I put this setback behind me. I had decided long ago not to dwell on rejection, either in my personal life or in my professional one.

To compensate for my disappointment, I focused instead on preparations for my solo exhibition at the Herbert Art Gallery in Coventry. This opened in the spring of 1995 and included 15 large-scale paintings, comprising four series of new work: six paintings from the *Wrap* series; two of the *Flock* paintings; five from the *Overlap* series; and two of the *Paragon* paintings.

In preparation for the catalogue essay, Rebecca and I discussed my paintings in the studio. I had no idea how she would interpret my work until I read her essay. Rebecca, who had studied English at Corpus Christi College, Oxford, before becoming a painter, had given the essay a rather enigmatic title, 'Heaven Can Wait', with an introductory quote from Emily Dickinson:

> *I cannot live with You –*
> *It would be Life –*
> *And Life is over there –*
> *Behind the Shelf*

Her essay commented on the two surfaces of my paintings: 'One side of the canvas proposes an infinite space, a space to step into, to escape to, to retreat to. The other side situates the viewer firmly in front of the work.'

She described the dappled space of some of my paintings as being like watching air: 'an image appears to dissolve as if we are seeing atoms'. I liked the analogy. Her interpretation of my work, with reference to science in this context, was also unexpected.

The exhibition at Coventry was a significant milestone in my career: the first time I had exhibited my paintings in a museum exhibition. At the private view, several people commented that my paintings were contemplative and sublime. Moreover, I had the catalogue from the show to promote my work and was sure that this would result in further exhibition opportunities.

Indeed, later that year I took part in a further three group shows: a charity exhibition at Christie's, in aid of the Imperial Cancer Research Fund; a group exhibition at the Atlantis Gallery in Whitechapel, with three other painters from my studio at Carpenters Road; and 'The London Group', a group exhibition in the Curve Gallery at the Barbican. This was good exposure for my work.

Yet, I needed to make time occasionally to do something other than art and to have a social life. Sometimes, it seemed my life was far too one-sided – I was always very aware of that. I spent most of my evenings preparing for gallery exhibition talks. Something had to change, but that change was not yet in sight. In fact, my work as a freelance art educator in London increased, alongside my studio practice, so I was glad to be busy.

Of the five projects I worked on in 1995, my favourite was Yves Klein's exhibition at the Hayward, 'Leap into the Void'. There was a real sense of anticipation and excitement about that show when it opened in London. Because of the fragility of many of the works in the exhibition, such a show was unlikely to be repeated. The gallery was transformed by Klein's intense colour and beautiful monochromes, his use of pure colour and space, and his vision of the void. In my gallery talks, I described the artist as a powerful and spiritual presence, a 'trickster'. I was deeply moved by his vision.

At the end of December, I was invited to give a talk about Emil Nolde at an exhibition of his work at the Whitechapel Gallery. Nolde is a German artist I knew very little about, but I grew to appreciate his work through looking at his paintings so intensely. The time and effort invested in researching Nolde's paintings was hugely rewarding. His dark and dangerous portrayals of the grotesque and the fantastical haunted my dreams – truly powerful works.

BRITISH ABSTRACT ART | PART 3

WORKS ON PAPER

FLOWERS EAST AT LONDON FIELDS AND FLOWERS EAST

282 & 199 RICHMOND ROAD LONDON E8
AUGUST 9 - SEPTEMBER 15 1996
TUESDAY - SUNDAY 10.00-18.00

ROGER ACKLING
RICHARD ALLEN
DOUGLAS ALLSOP
GILLIAN AYRES
CHRIS BAKER
W BARNS GRAHAM
BASIL BEATTIE
GEORGE BLACKLOCK
SANDRA BLOW
STEPHEN BUCKLEY
SIMON CALLERY
PRUNELLA CLOUGH
BERNARD COHEN
DAVID CONNERN
MIKEY CUDDIHY
IAN DAVENPORT
ROBYN DENNY
PHILIP DIGGLE
JANE DIXON
JENNIFER DURRANT
PETER ELLIS
JULIA FARRER
NOEL FORSTER
MARK FRANCIS
TERRY FROST
WILLIAM GEAR
MICHAEL GINSBORG
SHEILA GIRLING

ANDY GOLDSWORTHY
ALAN GOUK
ALAN GREEN
NIGEL HALL
CHRISTINE HATT
PATRICK HERON
ANTHONY HILL
DEREK HIRST
CLYDE HOPKINS
JOHN HOYLAND
MALCOLM HUGHES
JAMES HUGONIN
PAUL HUXLEY
BERT IRVIN
TESS JARAY
TREVOR JONES
PETER JOSEPH
MICHAEL KIDNER
DAVE KING
PHILIP KING
EDWINA LEAPMAN
ROSA LEE
KIM LIM
JOHN LOKER
RICHARD LONG
JOHN MCLEAN
JOHN MITCHELL
MICK MOON

MALI MORRIS
HENRY MUNDY
SALLY MUSGROVE
DAVID NASH
PAUL NEAGU
VICTOR PASMORE
FRED POLLOCK
REDO
ALAN REYNOLDS
BRIDGET RILEY
CAROL ROBERTSON
VERONICA RYAN
SEAN SCULLY
YUKO SHIRAISHI
DILLWYN SMITH
JACK SMITH
RICHARD SMITH
TREVOR SUTTON
WILLIAM TURNBULL
IAN TYSON
JULIE UMERLE
MARC VAUX
KATE WHITEFORD
RACHEL WHITEREAD
ALISON WILDING
GARY WOODLEY
GARY WRAGG
AINSLIE YULE

Aside from gallery education, a milestone occurred for my work in January 1996 when I exhibited one of my paintings in a group show at the Pentimenti Gallery in Philadelphia, the first time I had shown a painting in the United States. I knew how important it was for my work to be shown as widely as possible outside of the UK if I were to achieve my goal of becoming an international artist.

Meanwhile, undeterred by my inability to join the MA European course at Winchester School of Art (though still smarting from the rejection), I applied to Parsons School of Design in New York City to study for a two-year MFA course in painting.

I had decided it was the right time to leave London to complete my formal art education. I knew very little about the various art colleges in New York and chose the school rather haphazardly, mostly because of its location with campuses in Greenwich Village and on Fifth Avenue.

In the spring of 1996, I received a phone call from the course leader at Parsons to tell me I had been offered a place, followed by an official acceptance letter that suddenly made it all seem very real. I held a United States passport so at least I would not need a student visa, but there was still a lot to do before I was ready to leave London.

Once again, I was excited about the future (although also a little apprehensive) and hopeful that a change of environment would reap dividends in my work. New York held such an important place within the history of abstraction that I knew I would benefit enormously from the experience of living there and immersing myself in that environment. I had been working as an artist in London for 18 years and felt that I needed a period of research to gather inspiration from a different source. A move abroad would shake up my practice.

I continued to work at full stretch in my studio despite the many practical things I still had to do in preparation for my move to New York. Yvonne, who had returned from her residency, was unable to spend as much time in the studio as she would have liked due to teaching commitments. So, for the rest of my time in London, I was able to rent the whole studio. It was a huge expanse of space for one artist and I needed to make the most of it.

I decided to apply to the London Arts Board for a grant to help me carry out one final project before I left: I outlined a proposal for an ambitious series of large-scale paintings (five paintings measuring 152 x 244 centimetres each), which would be the biggest canvases I had ever worked on and physically very demanding. I did not know when I would have another chance to paint on such a scale and without funding I would certainly not be able to proceed.

At the beginning of 1996, I received notification from the London Arts Board that I had been awarded a grant which would enable me to go ahead with my plans. This project occupied me for the rest of my time in London. I bought stretchers, canvas and paint and made five enormous paintings. I was invited to show the *Stutter* paintings (the title of this series) at UNESCO in Paris where I had been offered a solo show.

Unfortunately, I could not find the backing to cover the transport of the paintings or contribute to the private view. Although the exhibition space was free of charge, I still needed to find sponsors to cover the additional costs and simply did not have enough time to do so. An application to the Lottery Fund was unsuccessful and, despite discussions with the British Council, I could not secure additional funding. The exhibition would have been an important achievement in my career. Few artists are invited to exhibit at UNESCO and I was bitterly disappointed to have been unable to take up the opportunity. The *Stutter* paintings remained stored in my studio in London, unseen for eight years. I sold one of them in 2004 and, in time, most of the other paintings sold too, but it took many years to place such large canvases and regrettably they have never been shown together as a series.

However, I did travel to Paris twice on the newly launched Eurostar to visit UNESCO in plans for the show. On one of those occasions, I visited the Pompidou Centre to see an exhibition by Francis Bacon. It was a fantastic experience. I especially enjoyed his *Three Studies,* the *Screaming Popes*, and his triptychs of George Dyer – 'dark meditations on love and death', as Michael Kimmelman described them.*

My last exhibition in London before I left for New York was at Flowers East in Hackney, a large group show called 'British Abstract Art: Part 3'.

* Michael Kimmelman, *Portraits: Talking With Artists at the Met, the Modern, the Louvre and Elsewhere* (Random House, London, 1998).

This included many well-known artists, such as Bridget Riley and Sean Scully. With this show, I felt I had achieved a breakthrough with my work as a mid-career artist, ironically just as I was about to return to full-time education.

I also had a group show scheduled in London for the end of 1996 at the Blue Gallery in Chelsea, although I knew I wouldn't be there to see it. Certainly, it looked as if I was beginning to gain recognition for my work just as I was about to change direction with my career, but I had already decided to leave London and had no regrets about that. Moving to New York to enrol as a student might be seen as a step sideways for a mid-career artist, but I decided it was a risk worth taking.

In the middle of August, I went to the Brixton Academy to see Nick Cave and the Bad Seeds play – part of my farewell to London. I've seen Nick Cave play many times since, several times in London, once in New York, and once at an All Tomorrow's Parties festival in Somerset, but that particular show in the summer of 1996 was very special. It marked the end of an era for me.

I already knew I would miss my family and friends when I left London and wondered if I would be lonely in New York – but that would be far from the case, as I was soon to discover. I arranged to rent my home to my sister, put all my paintings into storage and sub-let my studio to another artist, in preparation for the biggest adventure I had ever undertaken. I had never even travelled unaccompanied on a plane, let alone spent two years in another country on my own. I fully expected to return to London at the end of the two years but knew that, when I did, my life would have changed forever, and it was unlikely that I would be able to pick up where I had left off, even if I wanted to.

My only contact in New York was Jenny Polak, an artist I'd met through the education programme at the Whitechapel Gallery. We had mutual friends in London. Jenny had earned an MFA from the School of Visual Arts in Manhattan, then continued on to the Whitney Independent Study Program. She lived in Brooklyn and had a studio on the Lower East Side. We spoke on the phone just before I left London and arranged to meet in New York.

Parsons had arranged accommodation for me in the student dorm in the East Village (apparently the hippest area of Manhattan) and, although I was not too keen on the idea of living in student accommodation, at least I had somewhere cheap and safe to live. I wondered how I would get around New York without my car, which I had come to depend on so much in London. But Jenny told me that Manhattan was very accessible for a wheelchair user and this would not be a problem. It was just one of the many challenges awaiting me on the other side of the Atlantic.

I bought a one-way ticket to New York, said a tearful goodbye to my family at Heathrow airport, and left London far behind. I flew Air India to New York, being the cheapest transatlantic ticket available. On board the plane, my old suitcase, stuffed to the brim with everything I thought I would need, burst open in the aisle as a flight attendant tried to lift it on to the baggage rack above. Air India kindly tied the suitcase together with string to keep my belongings from falling out and I arrived in New York like many a poor immigrant before me, clutching a broken and battered suitcase.

Chapter Seven | **Parsons School of Design**

As the plane touched down on the runway at JFK airport, a moment of panic hit me, along with the most excitement I've ever felt. Leaving the plane for the tropical heat of a late August day in New York, with 90 per cent humidity to match, I was greeted by one of the airport staff who noticed how my legs were shaking with fear. 'Just relax,' he told me casually. 'You're in New York now.' Strangely enough, I immediately felt at home. The last time I'd been in New York was when I was five years old, boarding a flight for London. The accents and the attitudes of the Americans seemed strangely familiar, buried somewhere deep in my subconscious.

I took a cab into Manhattan. My driver told me that he originated from east London (of all places) and took good care of me, depositing me safely at Loeb Hall, the student accommodation in the East Village, which was to be my home for the next nine months. The ride into New York was amazing. Like all new visitors to Manhattan, the journey from the airport to the city was my first taste of what lay in store – that feeling of 'I'm here now and this is where it all begins'. As we arrived in the centre of town, I stared in awe at the landmark buildings I had only seen in movies, in photographs, or on television.

Downtown at Loeb Hall on East 12th Street, I shared a suite with two other students, both undergraduates in their early twenties. Lauren studied fashion and Hettie studied Liberal Arts. My room was a double room (I was given a little more space to accommodate my wheelchair). The other two single rooms in the suite were considerably smaller. We shared the kitchen and bathroom and, of course, there was air conditioning throughout. It all felt rather institutional, but Loeb Hall was situated in a fantastic location in the East Village.

That night, extremely jet-lagged but too excited to sleep, I went out to St Marks Place, where a video promotion of a single from REM's new album was being projected on to one of the buildings, accompanied by a loud sound system. My first night in New York. On my way back to Loeb Hall, I watched the clouds of steam rise up in the middle of the roads that I'd seen in *film noir* movies. It all seemed unreal, no doubt compounded by my jet lag, and I felt like I was on a film set.

When I got back to my room that night and turned out the lights, I noticed the previous occupant had stuck luminous stars and planets on the ceiling – a nice touch. My next-door neighbour kept her television on all night so she didn't get homesick. I didn't have a television or a phone in my room, but just being in New York was enough for me.

The next day, a Sunday, I tried to orientate myself in my new surroundings, enjoying the delis and the coffee shops, wandering the streets and staring up at the tall buildings most of the time. I had Frank Sinatra's song 'New York, New York' playing in my head all the time. I found it easy to find my way around town because of the geometry of the streets (and I'm someone who gets lost very easily). The East Village is a student location and most of the people living there wore baggy jeans, tattoos and piercings: I was far too sophisticated to blend in. I bought the Sunday edition of the *New York Times* and sat reading it outside a coffee shop in The Village.

One of the first things I noticed, as well as the intense heat, was the extreme energy of the city. Each time I went out of my building on to the street, people hurried by with great urgency. I found that I picked up the pace too, almost instinctively. There seemed no time to lose. But I also noticed how people stopped and spoke to strangers as if they were friends, and there were always little dramas going on if you stayed long enough to observe them. It seemed very odd after living in London where people are so reserved and self-contained.

Later, on my first day in New York City, I went to Tomkins Square Park on the Lower East Side to see how New Yorkers spend their Sundays. This had the biggest trees of all the parks in the city and offered some shade from the unrelenting heat. People were relaxing: listening to music, playing ball games, on skateboards or roller

skates. There were street theatre performances in the park too. A real mix of characters. I bought pastries from the nearby Italian bakery to eat later in my room, still fighting jetlag. The supermarkets confused me with choices and it was a week or so before I found things I could eat as a vegetarian – deli takeaways, pizza or diners were easy options.

What amazed me most about New York was how easy it was to get from one place to another without using a car or public transport. Everywhere was within walking distance and on a relatively flat terrain. I think it is actually the most accessible city I have ever lived in, despite the difficult surfaces of some of the pavements and roads in the poorer parts of town. Each street has a coffee shop and several delis and restaurants. There is continual bustle and noise, which never for a moment stops, even during the night – like a soundtrack that just goes on and on, repeating itself.

With my first weekend in New York behind me and having explored my immediate neighbourhood, I turned my thoughts to what it would be like to be living as a student there. At Parsons, each department has its own life – fine art students, architecture students, fashion students, drama and music students – and they rarely interact. But because I lived in the dorm, I came into contact with students from other disciplines – although they were all much younger than me. I wondered what the students would be like on the MFA course; what our studios would be like; what the faculty would be like; would they like my work; would I fit in? I wondered what kind of work the other students made.

On Monday morning, I registered at college – a long and complicated procedure. Parsons had sent a student from the Fashion School to help me through my first day, which was very thoughtful. Otherwise, I would not have known how to get through the process. Betsy showed me where the school offices were and how to negotiate the paperwork, moving swiftly from line to line and from building to building, everyone intent on doing exactly the same thing. The whole process took several hours, and we were due to be at the Fine Art department on East 13th Street in the early afternoon. Betsy told me she was sure I would do very well in New York. She liked my attitude (which I would need plenty of in New York) and she seemed impressed by my spirit as we fought our way through the throngs of new students at registration.

I met my fellow MFA students on the fifth floor of the Fine Art department. These were the people I would spend the next two years with. All of them were under 30 years old and had not long completed their BFA, but I didn't feel the age gap and couldn't have wished for nicer people to spend time with. We were a small group on our floor, 12 painters in my year and six in the year above. The sculpture students worked on a different floor, although we were together for the theory classes and some of the critiques. We were assigned our own small studios by picking the numbers by lottery.

Then, we prepared our timetables for the forthcoming semester. It was a busy schedule. As well as studio practice, there were two theory components and a drawing class to sign up to, in addition to the weekly 'Critical Directions' seminar run by Mira Schor. Philosophy plays a big part in the theory of fine art so I should not have been surprised at how important a role it occupied in the MFA curriculum, but I did question what Heidegger had to do with painting. I'm still not quite sure of the answer. ('The answer is hidden,' as one my friends observed.)

There were crits with our peers throughout the course, as well as studio visits by faculty and staff. The crits were one of the most important aspects of the course and a way to encounter and develop critical dialogue about our work. With all this to contend with, I wondered how we would ever find time to paint.

Our timetables arranged, we moved into our studios, painted the walls and floor, and began to plan our first paintings. This involved making lists of materials and exploring the local art material shops. I was still adjusting to the relentless heat and humidity of the late summer but I loved being able to make my way between the dorm and the studio each day without having to use my car. Parsons was close to where I lived and I enjoyed passing through Union Square on my way to college – particularly on market days when the farmers from upstate brought their produce into the city on trucks.

I was soon leading a completely different life from the one I knew in London. One of the most immediate changes I noticed in my daily routine was that, because food was cheaper in New York, it was possible to eat out

more often on a regular basis. It was much more fun than cooking at home and a lot more sociable. This is a regular part of most New Yorkers' lives, but much more of a luxury in London.

As for my MFA course: at first, I found it difficult to paint in my new studio, having enjoyed a much larger space in London. I also found it difficult to talk to the tutors about my paintings because they did not know my work. I felt like I had left my history behind in London, along with the context for my paintings. Yet, with no baggage, I started afresh. A conversation has to start somewhere. I began to paint on much smaller canvases (only 30 centimetres square at first) and to work on paper. My recent paintings in London had been about scale and high-keyed colour and now, by working so small, I felt that my work had lost its impact; but I had to find another way forward. This in itself was a challenge.

At one of our first studio meetings, we each gave short presentations of our work. All the new students were eager to engage in dialogue about each other's work, but I was at a loss to know how to discuss some of my peers' work and felt a little intimidated by the confident and forthright attitudes of many of the students. I think that at first I might have appeared diffident or reserved, typically English. In fact, I was neither of those things, just hesitant. At art school, it's all about being critiqued. You have to get used to giving and receiving criticism and you have to learn how to develop a thick skin to deal with it.

After my first week at college, I met up with Jenny, who visited me at Loeb Hall. I told her how difficult I was finding it, working in such a small studio, living in the dorm, and adjusting to being a student again. I probably hadn't realised the practical difficulties that would be part of that adjustment. But we both agreed that the degree course itself was not the only reason for being in New York; I had so much to learn from being there in other ways that would surely feed into my work.

Then, another important lesson – we went out to Fourth Avenue on our way to Battery Park for my first attempt at using the buses. I had rarely used public transport (and certainly not on my own) but I found it to be a very democratic way of getting around where the passengers are a real mix of people.

Jenny told me how useful the buses are in New York and what an accessible form of transport they are for wheelchair users. As we waited at the bus stop, I saw one of the buses approach and signalled for it to stop. The bus screeched to a halt and the driver ambled casually down the length of the bus to take me on board. The other passengers didn't so much as turn their heads to see a wheelchair user getting on – it was just part of everyday life to them – but I thought it was amazing to have the freedom to travel as easily as anyone else. For this, I had to thank the Vietnam Vets for asserting their civil rights when so many of them came back wounded from the war in the 1960s and campaigned for equal rights. The M6 bus followed Broadway all the way down to the southern tip of Manhattan where Battery Park was the last stop on the route, passing SoHo, Chinatown and the Financial District along the way.

In Battery Park, Jenny and I walked along the Hudson River. When I first saw the Statue of Liberty, I thought of my parents and all the other immigrants who had looked to her as a symbol of hope on their arrival, in exactly the same way that I did now.

Later, we stopped off in Chinatown to eat noodles. On our way back to the East Village, on a sultry New York evening, we passed the basketball courts and hip-hop kids, everyone out and about on a summer's evening making the most of what life had to offer. It had been an extraordinary first week, I thought.

Once I felt confident about using the buses, I was able to venture further afield, but it was several weeks before I left my immediate neighbourhood. Regina, one of our course leaders at Parsons, said she thought students got nosebleeds when they went above 32nd Street.

Although the buses were accessible, most of the subway stations were not, and some of the neighbourhoods in New York were rather difficult to negotiate – the numerous potholes and difficult terrain of the Lower East Side and TriBeCa were especially challenging. But it was the attitude of New Yorkers towards people with disabilities that I noticed most. They were far more accepting of difference than Londoners, far kinder.

One of my first visits midtown was to the Museum of Modern Art. Parsons gave its students free passes so we could visit the museum as often

as we liked. At MoMA, I was impressed by the size and abundance of the paintings and the sheer space of the galleries. The 'American Art' show at the Royal Academy had given me an idea what it would be like to be surrounded by so many iconic paintings, but I was in no way prepared for what I actually saw. I was completely overwhelmed. One of my favourite paintings is Barnett Newman's *Vir Heroicus Sublimis* (1950-51). To be in the presence of such a painting, a 5.2 metre-long canvas, was quite extraordinary. The painting unfolds in time, just as slowly as a Rothko painting does, and it can only really be appreciated in the flesh, I thought.

I also visited the Guggenheim Museum as I grew more confident about exploring midtown. This space-age rotunda with its circular galleries is an extraordinary piece of architecture and looks as futuristic from the outside as it does from the inside. Then, on Museum Mile, I finally reached the Metropolitan Museum which became my favourite place in New York. On my first visit to the Metropolitan, I promised myself that I would explore each room before I left New York. I got as far as the Egyptian Temple, the Temple of Dendur, before realising it would take many visits to achieve that goal.

Afterwards, I crossed the street to Central Park and sat down on one of the benches for a while, lost in thought. For the first time in weeks, the noise of the city receded and, for a short while, subsided. It seemed, for a few precious moments, that the world stood still on its axis and stopped spinning. In London, I'd heard that Central Park was a dangerous place, but I was relieved to find it was not.

In addition to painting in the studio and exploring the city, I joined evening classes at Parsons, trying to update my conversational skills in French, which had all but disappeared. I became a member of the Alliance Française on 60th Street, which I attended regularly throughout my time in Manhattan. One rainy Saturday, I spent an entire day watching a Jules Verne festival in the cinema – something I would never do in London.

At Parsons, trying to grapple with philosophy and taking on board new ideas and concepts on an almost daily basis, as well as the complete change in my surroundings and environment, shook me out of my complacency. The studio routine I had so carefully built up in London was completely broken apart.

There were crits on an almost weekly basis with faculty or visiting artists. Sometimes we would even show unfinished work to each other, a measure of trust in our peers. I was the quiet one in our group, known for being the most sensitive. In discussions about concepts and ideas, I would always have a response in my head but rarely voiced it, while other students were quick to make their opinions known. One of my tutors said she thought I feared confrontation – perhaps she was right. My life had been full of confrontation for as long as I could remember.

One evening in September, at the start of the new gallery season, I went to the Dia Center in Chelsea with some of the other students to see two films by Gordon Matta-Clark projected on its roof. On the rooftop, with a clear view across the river, Dia screened *Clockshower* (1973) and another of Matta-Clark's site-specific films, *Splitting* (1974), that showed an abandoned building being sawn in half. These performances introduced me to the idea of entropy, a concept I thought a lot about in the coming months and which led to my interest in Robert Smithson's work. Although his work did not appear to have much relevance to my painting, I was very attracted to its premise.

Exploring the galleries in New York was quite overwhelming: I have never seen so many galleries in one place. The art scene differed significantly from the one I knew in London. There was room for everything in Manhattan but still not enough space for the thousands of artists who congregated there, hoping to exhibit their work. The New York Gallery Guide lists hundreds of shows – streets of galleries and several floors of buildings in each street – containing art of all descriptions. The sheer quantity of exhibitions adds to the wealth of creative stimulus. There was so much to see and absorb that I was in fear of overload.

I had forgotten how to be a student after such a long time and soon discovered that it was all about being open to ideas. I had been an educator in London but being a student was an entirely different experience. I tried to follow John Cage's rules for teachers and students, a useful guide that I pinned up in my studio.

RULE 1: Find a place you trust, and then try trusting it for a while.

RULE 2: GENERAL DUTIES AS A STUDENT
Pull everything out of your teacher.
Pull everything out of your fellow students.

RULE 3: GENERAL DUTY AS A TEACHER
Pull everything out of your students.

RULE 4: Consider everything an experiment.

RULE 5: Be self disciplined.
This means finding someone smart or wise and choosing to follow them.
To be disciplined is to follow in a good way.
To be self-disciplined is to follow in a better way.

RULE 6: Follow the leader.
Nothing is a mistake.
There is no win and no fail.
There is only make.

RULE 7: The only rule is work.
If you work it will lead to something.
It is the people who do all of the work all the time
 who eventually catch onto things.
You can fool the fans – but not the players.

RULE 8: Do not try to create and analyze at the same time.
They are different processes.

RULE 9: Be happy whenever you can manage it.
Enjoy yourself.
It is lighter than you think.

RULE 10: We are breaking all the rules, even our own rules and how do we do that?
By leaving plenty of room for 'x' qualities.

HELPFUL HINTS: Always be around. Come or go to everything. Always go to classes.
Read everything you can get your hands on.
Look at movies carefully and often.
Save everything. It may come in handy later.

Fortunately, the other students were very welcoming and we often spent evenings together out on the town. For the first time in New York, I began to appreciate jazz, a truly American music. Jazz is everywhere, played at all the museum openings and in the many coffee shops and clubs around town. I learned to broaden my musical tastes. I didn't miss having a television either, which is something I thought I would: I watched far more movies in New York than I ever did in London. Someone once asked why anyone would want to watch television when they're a student in New York. There just wasn't enough time.

There was also a varied programme of lectures and talks at The New School, which were often sold out. One evening, I was lucky enough to get a ticket to hear Allen Ginsberg give a talk about his poetry. Ginsberg shared experiences about his life and work along with a slide show of photographs and a short poetry reading. It must have been one of the last performances he gave in New York City before he died later that year. Ginsberg lived in a modest apartment on the Lower East Side and was already in poor health. I was privileged to hear him speak and had always admired him because he epitomised the freedom of the beatnik culture I had read so much about.

In our theory classes at Parsons, we studied philosophers such as Jacques Derrida, Michel Foucault, Jean Baudrillard and Walter Benjamin, among others, all of whom I found difficult to comprehend. In fact, I struggled with theory throughout my time at Parsons.

At the end of our first semester, we each had to write a paper about our work, using some of the concepts we'd explored in class. I decided to write about something that had been central to my practice for years: freedom and control. I found that exploring ideas outside of my usual terms of reference forced me to expand my thinking and proved to be a very useful exercise, despite my initial reservations.

In the paintings I made at Parsons, I began to move away from the recent work I'd made in London. Exploring a new approach, I used oil and acrylic as a 'resist' to each other, the two materials being incompatible. This interaction of materials introduced chance into my work as an element of the process. My first successful paintings,

made near the end of the first semester, were a series of silvery white paintings that looked ghostly with a patterning of their own making. I know I would not have reached this point, and my paintings would not have developed in this way, had I continued on the path I had set out on in London. The new circumstances and conditions in which I worked completely changed the course of my development. My time in New York was an opportunity to start again and I tried hard to capitalise on the time I spent there.

Meanwhile, towards the end of the year, I heard from the directors of the Blue Gallery in London, where one of my pieces was being shown in a group exhibition. They wrote to tell me that the curators of Deutsche Bank had shortlisted my painting, along with several other artists, for purchase. I sent a selection of slides, as requested, for further consideration and, although Deutsche Bank did not buy my work at that point, it was an invaluable introduction.

In early November, a rather extraordinary event occurred at the Metropolitan Museum, after I had been in New York barely three months. I met a New York litigation lawyer, Michael, who asked me out to dinner. It was the kind of encounter you read about in trashy novels or see in romantic comedies. We had both been to see the Corot exhibition that afternoon and met by chance as we were leaving the museum. I discovered that Michael was a writer in his spare time. We shared similar tastes in literature, art, music and ideas. Following that first meeting at the museum and after a long phone conversation, we agreed to meet for dinner. Over dinner, one of the things we talked about was the paper I was writing for my philosophy course: I don't remember the date as a romantic encounter. The next day, Michael left a package of books for me with my doorman while I was out at college – guaranteed to impress. He was courteous and eager to please.

In the weeks that followed, we often went out to eat or to see movies together. Michael lived on the Upper East Side and was a few years older than me. He was very different from the people I was meeting at the time and our lives were very different from each other's. He worked in the corporate world and I was an art student, yet I was amazed at

how easily we connected. He had an analytical mind which seemed to work on an entirely different level from mine. I found that very attractive. Michael told me that, when we first met, he felt like he was 'walking on air' – a very good sign, I thought.

In late November, as the winter set in, I had no plans to celebrate Thanksgiving because I was busy finishing my end of term paper. But I was invited to a 'pot luck' supper in Loeb Hall and I somewhat reluctantly decided to go along. Everyone brought food to share, some cooked especially for the occasion, which we pooled together to make a feast. Then they introduced me to a Thanksgiving tradition: we went around the group, each saying what we had to be thankful for. When it came to my turn, I told them I was thankful that there was vegetarian food to enjoy and friends to enjoy it with. It was my first Thanksgiving Day in New York and all my Thanksgivings after that were special occasions.

Over the Christmas holidays, my sister visited me from London. She was staying at a hotel in Gramercy Park, a few blocks from Loeb Hall. We did all the things that tourists do in New York during the holidays: Christmas shopping at Bloomingdales, visiting the Twin Towers at the World Trade Center, catching a Broadway show on 52nd Street. Michael took us out to lunch one day at the Metropolitan Museum and, afterwards, wrapped up against the cold, we went to Central Park and watched the ice skaters on the rink. It was quite magical. Later, we visited the Cedar Bar where the Abstract Expressionists had gathered, drinking in the same bar as some of my heroes, but it was rather disappointing, a somewhat dark and uninspiring place.

We took the train to Connecticut from Grand Central Station a few days before Christmas to spend the holidays with Dad and my stepmother. Dad had lived in Connecticut since he first emigrated to the United States in 1952. He had taken American citizenship many years earlier and had remarried twice. This was the first Christmas I'd spent with him since I was a child. It felt rather strange and very unfamiliar. However, Dad was happy to have us with him and very welcoming. I wondered how different my life might have been if we had stayed together as a family throughout my early life, or at least if I'd had more

contact with my father as a child. Would I have been a different person? Undoubtedly.

When we returned to New York from Connecticut just before the New Year, we took the subway out to Coney Island on a bitterly cold day. The funfair, one of its main attractions, had closed for the winter, along with its renowned sideshow. In the summer, Coney Island is crowded with throngs of visitors. Now, the boardwalk was almost deserted and the cold Atlantic wind raged around us. We stopped at Nathan's Famous hot dog store to buy coffee and snacks before heading back to Manhattan.

On New Year's Eve, we waited at Times Square with all the tourists to watch the ball drop at midnight. We staked out our places among the crowd for maybe four or five hours in freezing temperatures. At some point that evening, one of the black cops who were policing the event ushered us into the doorway of a nearby shop to warm ourselves for a few minutes, telling the security guard at the entrance: 'These are my people'. New York is a climate of extremes, unbearably hot in the summer and bitterly cold in the winter. I have never been so cold as I was that night, but such an experience happens just once in a lifetime. The countdown to midnight in Times Square was worth the wait – caught up in the frenzy of the crowd with smiling faces, confetti, balloons, and kisses for all.

The next day, as we stepped out for an afternoon stroll on our way to Washington Park, someone approached us on Broadway to wish us a Happy New Year – as everyone was doing that day. He introduced himself as Will and invited us to join him at a nearby coffee shop, which we declined. I told him I was living in New York, that I was a student at Parsons. We exchanged pleasantries and he gave me his business card, chatting for a few minutes before we crossed Broadway. I saw from his card that Will lived on Central Park. That evening, I wrote in my diary about 'the creep' we'd met outside The Strand book store – a phrase that would come back to haunt me several months later. At the time, it seemed a rather odd encounter, though not particularly significant.

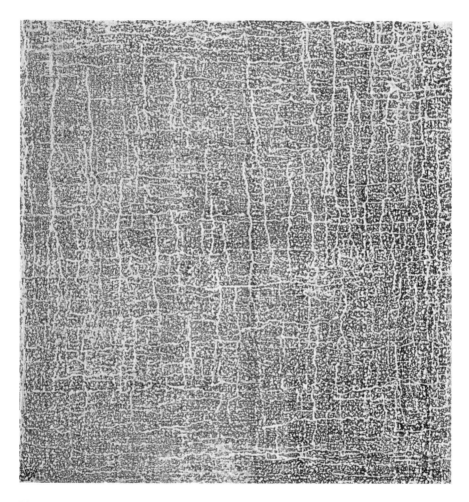

Maze. 1997. Oil and acrylic on canvas. 65 x 57 cm

Before my sister returned to London, we bought tickets to see *Hansel and Gretel* at the Metropolitan Opera House. I wore a glittery 1940s-style dress purchased from a vintage clothes shop in Manhattan for the occasion, but was surprised to find that no one else had dressed up. I had never been to an opera before and had expected it to be a very formal occasion. It was not at all how I had imagined. Our evening at the Metropolitan Opera House proved to be a fantastic and memorable experience that topped off an extraordinary holiday.

Although I had enjoyed the break, I was eager to get back to my painting. In fact, I was back in the studios as soon as my sister left town. The winter vacation at school was four weeks long and officially the spring semester did not begin until the third week in January. Some of the students had left New York for other parts of the country, so it was strangely quiet working in the studios without them and without the structure of classes. It was, however, a good opportunity to paint without any distractions.

That first winter in New York, I saw more snow than in my entire life, but the city was used to dealing with such wintry conditions. The pavements were swept clean, the buses still ran, and it was possible to go about one's business as normal, even for a wheelchair user. In fact, it was quite exciting to brave the weather and continue with day-to-day life, despite the snow blizzards that in England would have brought London grinding to a halt. Soon the students returned to college after the winter break and we resumed classes.

In the spring semester, we studied film as part of the term's theory component and watched Hitchcock movies in the classroom as an example of 'pure cinema' that referenced Walter Benjamin and Gilles Deleuze's concept of modernity. In addition, we saw several of Fassbinder's films at MoMA, showcasing a terrific selection of art-house cinema as part of the 'New German Season'.

I loved the movie theatre at MoMA: its innovative programme, and the arty crowd it attracted. On one occasion, a friend and I sneaked a muffin into the theatre to share during a film. As we carefully unwrapped it, a woman sitting in the row behind us reprimanded us loudly, shouting

'no eating in the theatre!' as though we had mortally offended her and everyone else in the vicinity. I heard that Susan Sontag had once admonished someone in the auditorium for talking during a film. They can be such a serious bunch, the New York intelligentsia, but I admired their ardent pursuit of culture.

At the end of the spring semester, when it was time to write my theory paper, I wrote about entropy, citing the example of Robert Smithson, whose work had first prompted me to explore the concept. I enjoyed doing the research and again reminded myself how important it is to remain open to new ideas and ways of working. Entropy was something I had never considered in relation to my own work and, even if it were not entirely relevant, it was an interesting subject to explore, and might lead to other ways of thinking.

I was happy with the direction my painting was taking and the way it had evolved. Most of my peers were supportive of my work, but my paintings often achieved a mixed response from the faculty. I didn't mind the criticism. In fact, it helped keep me grounded and encouraged me to work harder.

One of the positive crits I received for my work was from Jerry Saltz, a visiting tutor. He wrote a weekly column for the *Village Voice* when I was a student and he is now senior art critic and columnist for *New York Magazine*. Saltz was always very enthusiastic and encouraging about my work. He described one of my paintings as looking like 'fucked-up formica'. He certainly has a way with words but the simile was intended to be complimentary.

At Parsons, it was important to work outside of one's comfort zone. I thought the drawing classes were particularly useful for finding ways to do this. In one of our projects, we used polaroids of everyday objects or photographs from books as source material. I had never planned a drawing in this way before, always preferring to work from imagination. For this project, I referenced photographs of the desert floor, using wax and acrylic to build up the surface, with pen and ink to draw the lines. It was a complete departure from anything I had ever made before and paved the way for other discoveries.

One morning in the middle of April, towards the end of the school year, I came into my studio to find a postcard propped up on my desk. It was from Will, the man I'd met on New Year's Day. He had found me through Parsons, had asked about me at the school office and tracked me down. I was duly impressed by his diligence and surprised he had remembered such a chance encounter. I thought I might at least have coffee with him in return. His card asked me to give him a call, suggesting we meet for a bite to eat.

We agreed to have dinner together. Despite my rather negative first impression of him, we seemed to get on well enough. He was a native New Yorker, some 10 years older than me, divorced, with two grown-up sons. He had been a film student in Southern California and his interests were travelling, art and literature. Over dinner, he asked if I had seen much of the States since I had been at college, but I had to admit that I had so far only visited Connecticut. I mentioned that I regretted not joining the school trip to Washington DC earlier in the year and he immediately offered to take me there to see the museums before I left New York in three weeks' time.

The next weekend, Will invited me to Atlantic City and, because I'd never been to a casino in my life, I rather impulsively agreed, although I didn't know how to play the tables. After that, we spent the next two weekends together.

In Washington DC, we visited the Phillips Collection, where I saw one of my favourite Diebenkorn paintings. We visited the Hirshhorn Museum and Sculpture Gardens, and the National Gallery with all its treasures, then made our way to Pennsylvania Avenue to see the White House.

We spent our final weekend together in Sag Harbor, Long Island. Everything had started so well between us, but I knew it was precisely because we had met as I was about to leave the States that we had so enjoyed being together. There were no decisions to make about the future.

When Will dropped me off at the airport, I really thought that would be the last I saw of him. I made no plans to see him again when I returned to New York after the summer. I had not even given him my address or phone number for him to contact me in London. As far as I was concerned, that's where it ended.

Untitled. 1997. Oil and acrylic on paper. 35 x 27 cm

Chapter Eight | **Possibilities**

Arriving back in London on the day after the general election where Labour had just won a landslide victory, there was a new feeling of optimism in the UK that was almost tangible, with promises of a new era and talk of Cool Britannia. I felt I was looking at all this from a distance, so far removed was I from my old life.

I had changed and everything looked different after being away for nine months. In fact, I couldn't understand how London could ever have been my home. The pace of life was much slower than in New York, as if I had shifted gears and been transplanted from one planet to another.

However, I enjoyed meeting up with friends and family, realising how much I had missed them. At first, it seemed a gap had opened up between us while I'd been away. Other people's lives had moved on without me, and I felt that we had grown apart in my absence, but it didn't take long to feel I belonged again.

In London, one of the highlights of the summer was at the Royal Albert Hall where Nick Cave and the Bad Seeds were playing. It was good timing because they had been the last band I saw before leaving London in August 1996. I had never been to the Royal Albert Hall before and was impressed by the splendour of our surroundings. My friend and I sat in a box draped with red velvet curtains at the top of the theatre and Nick actually gave a shout out to us – 'to the girls in box number nine' – when he was on stage. Incredible. A fantastic night of music.

I had been painting at full stretch over the last year and now needed a chance to regroup. I was happy to spend 'down-time' over the summer, working on paper and planning a new series of paintings for when I returned to college. Although I had sub-let my studio at Carpenters Road, I went back to visit one of my artist friends who had been my neighbour in

the starter studios there. I enjoyed seeing the progress she had made in her work since I had been away. At the studios, I felt a strange sense of detachment from a place where I had spent so many years: another artist had already taken my space and made it her own.

During the summer, I thought about my first year in New York. Most importantly, I was happy with the direction my paintings were taking, and the positive effect the change of environment had on my work. I felt optimistic about the future. I knew how lucky I had been to live in New York, a chance that most people don't get, and my quality of life there was so much better than in London. I knew it would be difficult to fit back into my old life again (even if I wanted to) and that I would always be discontented if I didn't at least try to extend my stay. When I first moved to New York, I had not intended to live there beyond the two years of my studies, but it seemed inevitable that I would want to spend more time in a city where I felt so welcome. I started to think about staying on in New York after graduation.

My relationship with my father had also improved in the previous year. We now saw each other every couple of months, spoke regularly on the phone and had spent part of the holidays together too. If I had not lived in the States, we might never have seen each other again. Dad was by now in his mid-seventies and was experiencing health problems. When we met up in New York or Connecticut, we tried to make up for lost time by talking about a past which we had been unable to share when I was growing up. The time we spent together was precious.

Over the summer, I reconsidered my relationship with Will. Although I didn't want him to visit me in London (he belonged to another part of my life and I was happy for things to stay that way), I wrote to thank him for our time together and gave him my phone number and address so we could keep in contact over the holidays. I had already decided that when I went back to New York, I would move out of Loeb Hall and find an apartment to rent. I told Will of my plans and he promised to look for an apartment for me while I was away.

I flew back to New York in August, and Will met me at JFK airport. He drove me to Manhattan to see the studio apartment he'd found

for me. It was in a pre-war building just off Union Square on East 15th Street, a great place to live. Andy Warhol's factory had been on Union Square and I loved the area. The neighbourhood had changed immeasurably since the late 1960s and 1970s when Union Square was known as 'Needle Park' and synonymous with crime and drugs. Then, people had been afraid to walk through the park. Now, Union Square was a very desirable neighbourhood and, more importantly, only a short distance from Parsons.

The entrance hall of my apartment block had once been rather grand, with walls of marble, a ceramic tiled floor, and chandeliers. Now, it had a faded elegance and charm. My tiny studio apartment was on the fifth floor. My apartment had a hardwood floor, a kitchen as small as a cupboard, a spacious bathroom with a marble tub, and good closet space. With no air conditioning, it was steaming in the August heat, but it was my first apartment in New York and I was delighted with it.

As I unpacked my suitcase, Will picked up my diary and opened it at the first page where I had written about our meeting on New Year's Day. I tried to stop him from reading it, warning that he would only read bad things about himself if he did, but, of course, he continued nonetheless – starting with my first entry on 1 January of that year where I had described him as 'a creep'. He wasn't offended and laughed out loud; he even seemed proud of how he'd turned the situation around and appeared to take it all in good spirits.

The next afternoon, Will drove me to Ikea in Brooklyn to buy furniture for my apartment. When we got back, he put up the blinds and started to construct the bookshelves we'd bought. The apartment was blisteringly hot. I was jet-lagged and wanted to sleep. Will just wanted to get the job done. We quarrelled and he stormed out of the apartment. Within two days of being together, it was all over between us. Although we continued to see each other from time to time, there was definitely no future for us. Will already had two girlfriends, which is why I knew from the start that we could never have a serious relationship. At least he had been honest and I had been under no illusions. My main priority in New York was my painting, in any case.

Back at college in my second year at Parsons, I taught junior painting class as Elke Solomon's teaching assistant one afternoon a week. This was useful experience for me and, more importantly, it paid a wage. Most MFA students in the States work at jobs outside college to pay their way through school. I was thrilled to be chosen because most of my fellow students had also applied. On several occasions I had the opportunity to take the class on my own, which helped to build my confidence. As a student myself, I could relate to the students on a more personal basis than many of the tutors and I built strong relationships with several of them over the course of the year, delighting in their achievements.

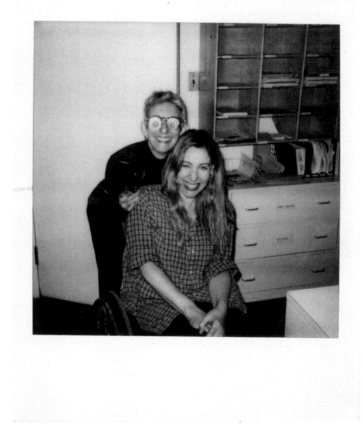

With Elke Solomon at Parsons School of Design, New York City. 1997

Generally, the classes would follow a familiar pattern. First, we asked the students to keep a diary of the exhibitions they'd seen throughout the week and, being New York, there was an abundance of galleries to choose from. We compared notes as a group, which often developed into lengthier discussions. There were specific tasks set each week to develop painting skills, as well as rigorous critique of the work produced, and each week we'd give the students a written text to study that we discussed in class (a text about an artist or an art movement or perhaps an article by an art critic). I enjoyed talking to the students individually about their projects as they worked. It was my first experience of teaching in an art school and I was lucky to have such a good mentor in Elke.

It was easy to keep informed of current trends in the art world through the many galleries in the city, and I enjoyed the stimulus it brought to my work. A mass migration of galleries had recently begun from SoHo to Chelsea. SoHo, which had once been the centre of the art scene with its many galleries and artists' lofts, was now largely a centre for shopping and designer clothes. I still went uptown to see some of the blue-chip galleries and to visit the museums, but Chelsea often showed younger, less-established artists. The galleries there were located close together, within a few streets of each other, and within easy walking distance of the college. I saw more exhibitions in New York in one year than I had ever seen in London.

There was also a fantastic opportunity to see live music in New York, which I tried to make the most of. I went to the Knitting Factory and Irving Plaza to see bands, and visited Radio City Music Hall to see Beck play one Valentine's Day. Another time, I got a ticket to see Nick Cave and the Bad Seeds play at the Beacon Theatre, seated right in the front row – almost too close for comfort. However, I didn't attend any concerts or events at the big stadiums while I was in New York, preferring the more intimate venues.

In my second year at Parsons, I started exhibiting in New York. I was included in two non-profit group shows: 'Night of a Thousand Drawings' at Artists Space and 'Generations' at A.I.R. Gallery (the women's collective co-founded by Nancy Spero). That year, our class visited Nancy Spero's

studio at her SoHo loft where she and her husband Leon Golub lived. Both artists were in their eighties and completely inspiring. Their creativity was still at peak level and they had a reputation for being generous and encouraging in their support of students and younger artists. Spero showed us her scroll paintings and talked about how her work had developed. She encouraged each of us to be brave in our careers.

My work continued to progress in the second year at Parsons, after a hesitant start. In the first year, I had gradually developed a way of working that brought an element of chance into my process and, in the second year, I built on that approach. At the beginning of term, I started a new project in my studio that I had been planning over the summer. In this project, I used three canvases to record the process of my paintings: two canvases were hung on the wall, one above the other; the third lay on the floor beneath them. I pulled a brush across the top canvas so that the painting beneath it captured the drips, while the canvas on the floor contained the marks of the whole process. Indeed, my studio floor had a history of its own, as did the marks on the wall around my paintings. That was the starting point for this particular piece. It wasn't necessary that the final product be a success (and actually the project didn't work out as well as I had hoped) but I had time to experiment and make mistakes and that was part of the fun of being a student. I did not really know at that point where my painting was going or how it would develop.

I decided to research fractals as a source for my paintings. I had always been interested in order and chaos and liked the idea of trying to relate science to art. I tried to understand the logic of science, but the world of physics was a foreign language to me. Exploring these ideas was fertile, nonetheless, and provided a rich source of ideas and vocabulary that added a new dimension to my paintings.

Many guest artists came through Parsons – established artists such as Sean Scully, as well as hot new artists like John Currin and Elizabeth Peyton (both new generation American figurative artists). My favourite visiting artist was, of course, Robert Ryman. His studio visit was memorable for a number of reasons. I could not believe how lucky I was to show him my work and have his feedback on my paintings.

Ryman was very unassuming, with a quiet authority. He introduced himself as Bob, shaking me by the hand as he entered my working space. He wore a suit and a pair of very cool spectacles. He was kindly and extremely modest and wanted each student to do their best whether their work was to his taste or not – which, in my view, is exactly what one should expect.

In his crit with me, Ryman talked about the value of looking at paintings in different lights (both natural and artificial lighting) and how the interior light in a painting is very important – think how Rothko's paintings have a light of their own. When he entered my studio, Ryman asked me to turn the spotlights off so he could see my work in natural light. He also observed that I already knew how to use horizontals and verticals in my compositions and commented that he thought I would do well in New York. Then he asked how I would title my paintings in an exhibition. He laughed when I told him one of my paintings was called *Creep* and said I shouldn't give emotional titles to unemotional paintings. He particularly liked one of my blue oil-and-acrylic canvases, which was a step beyond the small white paintings I had made in the first year. It was one of the few large-scale paintings I made in New York. I still have that painting stored in my studio all these years later and will always think of Ryman's comments when I look at it. His studio visit was one of the highlights of my time as a student in New York.

Elizabeth Peyton was another of the visiting artists I particularly enjoyed meeting. I liked her portraits of pop icons such as Jarvis Cocker and Kurt Cobain. She said I spent too much time in the studio and made too many paintings. I was surprised at her comments: most tutors will tell a student to make more paintings and work harder in the studio. Peyton insisted that an artist's life doesn't stop at the studio door and that it is just as important for one's practice to experience life outside of the studio as it is to make work, particularly if you happen to be in New York.

Sean Scully's critique was much more the kind I would have expected to receive at an art school in London, referencing contemporary British painters such as Ian Davenport and Callum Innes. These artists were never mentioned by American tutors when discussing my work. It made

me wonder how my paintings would have developed had I studied for my MFA at a London college and whether my work would have been received differently within such a context.

At half-term, I flew to Canada to spend a few days with a friend from my early student days at Sussex University, an economist who now lived in Ottawa and was married with two teenage children. This was the first time we'd spent so much time together in years. We watched her daughter play in an ice hockey match and spent time with her husband and son, walking in Gataneau Park, where I enjoyed the clean air, lakes and autumn leaves that looked picture-postcard perfect. I learned about the Group of Seven in the National Gallery of Canada, appropriately enough.

The family were curious about my paintings (which they had last seen some years earlier in London), so I came prepared to give a slide show about my work, which they really enjoyed. And it was good practice for a presentation I had to do at Parsons the following week. My trip to Canada was the only time I spent outside of New York that year.

In the final year at college, we were all beginning to feel the pressure. I continued to enjoy life outside the studio, making the most of what New York had to offer. Gallery and museum visits remained an important part of my studies, as well as artist talks at galleries. At MoMA, I attended two of the 'Conversations with Artists' events, where one of the speakers was John Currin, a visiting artist at Parsons. He discussed his influences and the development of his paintings, then led a tour of the galleries, citing *Les Demoiselles d'Avignon* by Picasso as his favourite painting in the collection. In another of these talks, Roni Horn discussed her work, with particular reference to her installations in Iceland. I liked the relative intimacy of these occasions, where tickets were limited and the lectures were targeted at a small audience.

MoMA also hosted symposiums, which were more formal occasions and an opportunity to observe the New York art world and many of its key players up close. I particularly enjoyed the symposium about the German artist Sigmar Polke. I liked the *Apparizione* triptych, which was shown in the gallery, where he allowed the stretcher bars of the paintings to show through a transparent surface, and his 'unpainted paintings', where he

poured different chemicals on to the surface and allowed the paintings to make themselves, as if by alchemy. This was a revelation to me, to learn how freely Polke approached process. These paintings were quite unlike anything I'd ever seen.

In the spring, I took a course entitled 'A Genealogy of Terms', where we studied key critical texts. At the end of term, instead of having to write a paper, we had to summarise each text. This was laborious and time-consuming but helped focus on important issues which were particularly challenging. Indeed, all the theory classes had been difficult to grasp and had really stretched my thinking. But whether I would remember any of the philosophy, or how it would affect my painting in the future, was a different matter.

After spring break, the last few weeks were spent in preparations for our degree show at the Brenda Taylor Gallery in Chelsea, where we would each include a few pieces of work. I exhibited three paintings – a 122-centimetre-square painting and two smaller pieces. The degree shows in New York were not as instrumental to an artist's career as they were in London at that time. In London, the end of year shows are always eagerly anticipated by dealers, gallery owners, curators and collectors who sift through the new MFA graduates in their search for the next generation of art stars. Many artists in London leave art school with the prospect of several exhibitions before them, having sold their show to eager collectors, and receive lucrative offers for the future based on their degree shows. Our show in New York was, in contrast, a rather low-key event, but a well-earned celebration of two years' work. I was very excited at seeing the work hang in the gallery, a culmination of so many new ideas.

After the thesis show, each student's work was assessed by five members of the faculty at Parsons. This was a more formal occasion. We each took turns to hang our paintings at Parsons as a solo show and were present at the faculty's discussion about our work. We provided an artist's statement and were given an opportunity to introduce our work, then listened as the members of the faculty made their observations and reviewed our presentations.

In my review, familiar references to transcendence and beauty were discussed. As expected, my paintings received a mixed response. Byron Kim thought the ideas behind my paintings were too ambitious and weren't fully realised in the work: he preferred my works on paper. Mira Schor questioned the role of chance and intervention in my work. Glenn Goldberg thought my smaller paintings less successful because they seemed over-determined. Of the more constructive criticism, Regina Granne pointed out the importance of viewing the paintings up close and suggested that my paintings would benefit from being worked on a larger scale, while Saul Ostrow's comments, I thought, were the most perceptive: 'These paintings are literally what they are and do not transcend their materiality, nor transcend any aspect of them, but are seemingly factual and somehow in that factualness constitute some sort of analogy, which is unordered, non-symbolic, just happens, matter-of-fact. Literally if these paintings were to succeed we should be able to say nothing about them. Here we have very much a series of decision-making and that's the matter-of-factness of them. We have decision after decision made apparent, in which we know that there's constant intervention on the part of the artist.'

Few of the students came away from the presentations feeling confident that their work had been endorsed because the review was not meant to provide that. The course gave its students a roadmap for the future but was not intended as an instant route to success: there are very few shortcuts to success in the art world.

Thus, in 1998, I graduated from Parsons with a MFA in painting. I knew that what I learned would be put into practice in the coming years. I had identified areas where I could improve and had been given an opportunity to re-assess my direction and refresh my practice. Perhaps most useful had been the opportunity to engage in critical dialogue about my work.

The two years I spent at Parsons marked a major shift in my paintings. Indeed, artists who work in other countries for any length of time – for example, in residencies abroad – often see a change in their work. Because of my particular access requirements, it would not be easy for me to find an international residency elsewhere. After I left

Parsons, I considered applying for residencies in Rome, Beijing and Berlin, but the studios all had mezzanine floors that would have been unsuitable for a wheelchair user and this seemed to be the standard layout. In New York, I had been given a valuable experience to spend time outside my usual environment – and I did not know if I would ever have that opportunity again.

At the end of the semester, many of my friends from college stayed on in New York. I had already decided to do the same. It was not such a big decision to make. I was not yet ready to return to London, without knowing what it would be like to live in New York as a working artist. I knew it would be a completely different experience from living there as a student. In New York, many artists, actors and musicians wait on tables, serve in bars and stores, or work as studio assistants. I wouldn't be able to do any of those things and it was always going to be a struggle to survive on my limited income, but it was worth the risk, despite knowing there was the possibility that I could fail spectacularly. I rented my flat out in London and had just enough money to pay for my apartment in New York, with a little over. I made up my mind that I would stay in New York until my money ran out. I have never been afraid of a challenge.

I renewed the lease on my apartment on 15th Street, which, although too small to paint freely in, was adequate for my needs. Michael, my ex-boyfriend with whom I'd stayed in touch over the past two years, had recently received an advance for a movie script. He offered to help me with the rent on a workspace for the first few months, and bought two of my small paintings – my first collector in New York. This put me in a stronger position. I knew I couldn't have set myself up as an artist without his support, which had been invaluable.

After graduating from Parsons, we were able to continue working in our studios right up to the first week of the new semester. This was a bridge between being a student and leaving art school and made the transition a little gentler than if we had had to move out of our studios at the end of term. Each week during the summer, I looked at the list of studios in the *Village Voice* or on noticeboards in the art shops but didn't see anything that suited me or filled my budget. Some artists were renting

lofts in Brooklyn, Queens or Long Island City, huge live/work spaces that were reasonably cheap, but I wanted to stay in Manhattan, where I was familiar with the neighbourhood and within easy reach of the galleries and other facilities. I had visited friends in their lofts outside Manhattan, but travelling there on the bus had been difficult, and I couldn't imagine living there. The lofts were spacious and a fantastic place to live and work, but I found it all too inaccessible. Certainly, if I were to stay in New York, it had to be in Manhattan.

Chapter Nine | **New York, New York**

The summer of 1998 was my first summer in New York. The previous year I had returned to London at the end of term and came back to the city at the end of August, thus avoiding the dog days of June and July. In midsummer, the sun hits the concrete with an awful intensity; the humidity is unbearable, and the coolest place is in the park. Many residents leave the city for the whole of the summer, go upstate or vacation elsewhere, or at least escape each weekend for Long Island or Massachusetts. There's a kind of madness at play in New York City over the summer, when tempers get frayed.

In June and July, I spent my days in my studio at Parsons with some of the other students, enjoying painting at a leisurely pace now that we had completed our degrees, the big industrial fans keeping the heat at bay. Days when the temperature reached 100 degrees (38 degrees Celcius) were hard to bear: I was not used to the stifling heat and felt as if my blood would boil, but there's camaraderie in adversity and everyone who shares memories of a summer in New York will never forget it.

Often, I would go out to Washington Square Park in the early evening, or to Chelsea Piers as the sun set, to cool down. One day during the summer, I met up with Elke to see the Frick Collection on Fifth Avenue, a wonderful collection of Old Masters. It was my first visit to the Frick – there was always more to discover in New York, even after two years. Then we visited the galleries on Madison Avenue. We talked about my plans to stay in New York. I still didn't have a clear idea of where I would work and time was already running out.

On 1 August, I flew back to London for a short break, just in time for the birth of my younger sister's fifth child, who arrived that morning. It was wonderful to be there in time to welcome my new niece and to be part of the family for that special occasion. I was used to travelling

on my own by air now and it no longer held any mystery for me. It was just a means to an end. That was another thing that going to college in the States had opened up for me, the freedom to travel. I became as accustomed to flying by plane as I was to using the bus.

When I got back to New York a week later, more determined than ever to make a success of my time, I found a studio advertised in the *Village Voice* that might be suitable for me to work in. It was close to where I lived and the rent was reasonable, so I put a deposit on it. The studio was on Sixth Avenue, a shared loft space on the fourth floor with a group of painters. There was another group of artists working on the second floor in the same building and both lofts were owned by the same landlord. The other lofts in the building were residential. The elevator in the building was old fashioned and industrial. I had to wind the lever by hand for the elevator to work, then it would judder to a halt at its destination and I would pull the heavy iron gates open to exit. I was fortunate not to get stuck in the elevator, as I heard someone once had.

There were about eight painters working on each floor. The loft had a large window that looked down onto busy 14th Street. My studio was at this end, where the light was very good. The studios were largely open-plan, connected to each other, and with a communal washing-up space at one end. I shared my space with another artist. The space I worked in was a little bigger than the one at Parsons. It was not ideal, but I was just relieved to have found somewhere to paint. I was looking forward to moving out of the studio at Parsons and living independently as a professional artist in New York, but in a way it felt like leaving home. Two dogs, a cat and an iguana (the landlord's pets) also resided in the studios on 14th Street, alongside the artists. Marijuana plants grew in pots on the windowsill of my studio.

It was a rather chaotic atmosphere, controlled by the presence of the landlord who lived on the premises. Many of the other artists who worked at the studios didn't come in until late afternoon or evening, so I usually had the place to myself during the day.

The studios were just a few blocks away from Union Square and close to the Meatpacking District, which was fast becoming a hotspot for artists

Painting. 1998. Oil and acrylic on canvas. 60 x 60 cm

Baby Blue. 1998. Oil and acrylic on canvas. 60 x 60 cm

with new galleries springing up all the time. At lunchtime, sometimes I'd go into one of the nearby lounges to buy coffee and bagels and watch the television, relaxing on big velvet sofas. It was the time of the Monica Lewinsky scandal and I clearly remember Bill Clinton's deposition being played out on the big screen in the bar.

I soon found that it was very different working as an artist in New York than it had been in London. My studios in the East End of London were always in rather inhospitable areas and in industrial locations some distance from the centre of town. The studios I had in New York were at the centre of everything. The traffic on the street formed a backdrop to our lives. Every imaginable kind of person co-existed on the streets of the Big Apple, with little dramas being played out on the streets all the time.

It often takes a while to settle into a new working space: this time was no different. I made one or two small paintings during the autumn that I was happy with. Others, I discarded. I began a new series of works on paper based on the desert floor drawings I'd made at Parsons in the drawing class and continued to develop these. I worked on two series concurrently (both paintings and works on paper) and tried to maintain a regular studio routine: painting in the studio on weekdays while it was light and visiting galleries and museums at weekends. Gallery visits had become an important part of my education at Parsons and I tried to continue this after I left college.

In order to make a little extra money, I started to do some administrative work for my landlord at the studio, but my computer skills were practically non-existent, and I made so many typing errors that my services were soon dispensed with. It reminded me of how miserably I had failed at the office job I had once taken in London. Office skills were never among my better skills.

A few months after I moved into my new studio on 14th Street, we had an open studios weekend, where we each hung work in our spaces. This was an annual event at the studios. Several of the people I knew from Parsons came to the opening, and I was proud to be able to show some of the new paintings I had made since graduating. At least I was still working as an artist.

Towards the end of the year, I was in a show curated by one of my classmates in his apartment on Riverside Drive, where he had started a gallery. He invited some of us to show work in a group drawing salon. I had never travelled as far as Riverside Drive. The bus took a long and circuitous route making its final stop at the Cloisters, which was still some distance from where I wanted to be. But the driver obligingly made a detour and dropped me off at a more convenient point. It was great to see so many of my classmates at the private view and an opportunity to catch up with what everyone was doing.

Now that I had a studio on 14th Street, my next priority was to try to get a gallery interested in my paintings and find one that would be right for my work. I know from experience that this is a formidable task, but my time in New York was short and I wanted to at least try to get some studio visits – to test the water, so to speak. My first studio visit was from Ivan Karp, who had been director at Leo Castelli in the 1960s and now owned OK Harris Gallery in SoHo. He liked my paintings and described my work as 'emotional minimalism' (which was something of a generalisation and seemed a contradiction in terms). I didn't follow up his visit, although he invited me to keep in touch.

I also had a studio visit from the directors of Rare Gallery, one of the new galleries that had recently opened nearby in the Meatpacking District; and from another of the new galleries in Chelsea, the Silverstein Gallery. Then, there was a studio visit from Eric Stark of Stark Gallery, where I had seen several interesting shows. Stark said he would make some recommendations to other galleries for me, which was certainly helpful and might be another way into the closed gallery circuit.

By chance, I met Tom Cugliani, director of the Marlborough Gallery, when I went to see Lydia Dona's work in an exhibition at their downtown space. I had my slides with me, as I was doing my rounds, and Tom took a look at them. He thought the work looked interesting enough to make a visit to see my paintings. That was exciting. The studio visit went well and he liked several of my paintings. If I achieved no more than that, a studio visit from the director of the Marlborough Gallery in New York was a moment to savour.

In fact, none of the studio visits in New York resulted in being offered a show. From my experience of studio visits in London, this was a bad percentage. It is difficult enough to get gallery directors to visit anyway, but I was surprised to discover that I had no better chance than any other graduate of finding a gallery to represent my work, despite my extensive exhibition record in the UK. My CV and education counted for very little in New York, without personal recommendation. I got the impression that an artist would need to be introduced to a gallery director by a third person. Although artists from London were very much of the moment, my work was abstract, not Brit Art or conceptual, so the fact that I came from London didn't help in the slightest.

In December, I asked Regina, one of our course leaders at Parsons, if she would visit my studio to look at my work. I missed the input of the critiques we'd had at college and looked forward to having her opinion of my new paintings. Sometimes I find it impossible to be objective about my own work. We met at my studio, braving the cold; New York was in the grip of a snowstorm of epic proportions that day, with people walking along 14th Street wearing balaclavas.

I knew Regina would tell me if my work was slipping. She singled out one 61-centimetre painting that she thought was one of my better pieces. She encouraged me to try and articulate why that particular painting was more successful than the others. Over the years, I had learned to trust my instinct and could be very stubborn, so it was useful to have someone look at my paintings in an analytical way, to comment on formal qualities such as colour relationships and spatial distances. Sometimes, if a painting worked, I did not try to find out why and was just happy with the end result. Once again, her critique made me question my work and what I was doing, which was extremely useful.

That winter, one of the artists I shared my studio with was singing in the choral society at Grace Church, the beautiful Gothic Revival-style church on Broadway. I went to hear the choir sing the Verdi Requiem. It was a fabulous experience – solemn and majestic. This inspired me to visit the First Presbyterian Church on 5th Avenue to hear Handel's Messiah a few weeks later. New York continued to be full of new experiences for me that, in turn, helped to open up my work. I think it's true that painting responds, however

subliminally, to an artist's environment. I tried to be open to as many new experiences as possible in New York.

By Christmas, I was beginning to feel a little downhearted by the lack of progress in my career. Although I was enjoying my studio practice and excited by the progress I was making, I had achieved very little in terms of finding a gallery, which had been my original goal. I would have liked to focus on my practice, giving no thought to how my career might develop, but that is not a practical option in such circumstances. With no employment, sales of paintings, or promises of exhibitions ahead, I was struggling to make ends meet. My sisters in London told me they thought I should come home.

I didn't have the luxury of being able to spend time in New York waiting for things to change. Sometimes an artist needs to dig in and just keep working until their luck turns. I spent years working as an artist in London after I first left college before I got any kind of recognition. There are always times when things look hopeless, when there seem to be no opportunities ahead. I was already living meagrely, on a diet of ramen noodles and peanut butter, in my tiny apartment. I was just one of many artists in New York, all hoping for a break. I found out what it was like to live amid the glamour and the glitz and to feel so poor. In New York, there is a sense of camaraderie among struggling artists that is not so great in London (or, at least, that is my experience). Most artists are ambitious but, in New York, there is also a shared sense of struggle that becomes almost a rite of passage.

In New York, although a mid-career artist, I found that I had to start right from the beginning again, just as I had in London when I first left college all those years ago. Pat Hearne, a gallery director I met briefly soon after I came to New York, told me that I needed to exhibit in alternative venues and non-profit spaces before I would ever have a chance of exhibiting with a commercial gallery. The group exhibitions where I had shown my work in New York were all in non-profit spaces, but I knew I would have problems moving up to the next level. I feared that I would sink without trace. However, I continued painting in my studio in the time I had left in New York, making that my priority, although I was beginning to feel rather dejected at the thought of having to return to London in the near future.

I spent Christmas Day with three of my friends from Parsons at an apartment in the Romanian Consulate on 38th Street, where one of them lived. We shared food and Christmas cheer, taking the bus back downtown in the evening through a quiet city. The year before, I had spent Christmas Day at an art-house cinema, watching a French movie with two of my friends and eating at an Indian restaurant in the evening. In London, it would be difficult to find a cinema open on Christmas Day. Such was the cultural difference between the two cities.

By New Year, I was beginning to concede defeat and knew for sure I would have to return to London when the lease on my apartment expired in the summer. Other students, who had been in my class, seemed to be surviving somehow, but they all had jobs to support themselves. One of my friends had been taken up by a good gallery in San Francisco soon after graduation; others were getting shows in New York. Everyone's careers were developing differently and at a different pace.

I continued painting in my studio on 14th Street, knowing the time I had there was short, but still enjoying every minute, despite the struggle in my day-to-day life. Will, who I saw from time to time, commissioned three small paintings from me for his apartment on Central Park. At least it paid the rent on my studio. The commission was quite open, restricted only to size and style. When the paintings were complete, I hung them in my studio and invited Will to take a look. He only liked one of the paintings and I had to repaint the other two. This was disappointing. But when I was finally able to complete the commission to his satisfaction, I wrapped up the paintings, took the bus to his apartment on Central Park, and left the paintings with his doorman with an enormous feeling of relief.

That spring, I was in a group exhibition in the Meatpacking District. There was a good crowd at the private view, and some of my neighbours from my apartment on Union Square came to see the show too. My friends from Canada visited me in New York during the exhibition, staying at the YMCA in midtown, so I was able to give them a glimpse into my life as an artist in the city. I showed them my studio, they saw my exhibition, then they visited my apartment, where we all sat together on a huge futon in the centre of the room – the only available seating.

I saw one of the children again when she visited on a trip with a school friend a little later in the year. I took the two girls to the Metropolitan Museum and then into Central Park. In the Met, we threw coins into the fountain and made wishes. I told them how I had done that when I first came to New York and how one of my wishes had come true – I didn't tell them which one it was though – and they were duly impressed.

In May, the second-year students at Parsons held their thesis show at a gallery in SoHo. It was interesting to see how their work had progressed over the last year. I was also invited to visit Parsons on open house day to see the new students' work. It felt rather odd to be back in my old studio. I felt quite territorial about my space, with the time I had spent there still fresh in my memory.

Aside from visiting my dad in Connecticut, I didn't leave New York that year – I simply couldn't afford to travel. However, on 4 July, I went to see the fireworks on the East River for Independence Day. This was the first year I had been in New York for the celebrations. It was a fine summer's evening. On my way to see the fireworks, I took the bus in the wrong direction and had to change course halfway through. From the window, I could see the buses heading in the opposite direction all packed with passengers and knew I was going the wrong way. Finally, on reaching the destination, everyone staked out places by the river to get a good view and waited excitedly for the display to begin: it was a bit like waiting for the ball to drop on New Year's Eve. The firework display was the most spectacular I'd ever seen – but I had only been to municipal firework displays in London before, so didn't have that many to compare it with. I clapped with delight as the first rocket exploded in the sky. At the end of the evening, the crowd dispersed and everyone drifted back uptown. The buses were full so I returned among the throng, looking up at the Empire State Building like a beacon in the distance as I slowly made my way along Broadway. I tried to fix this picture in my mind, to look back on in the future. A special moment in time.

There were often reminders of my life in London, despite being far from home. One evening, at a private view at the Sean Kelly Gallery, I met Jane Hamlyn from Frith Street Gallery, who had taken some of my work

to show her clients in the early 1990s when she first opened her gallery. We spoke rather awkwardly – I wasn't sure if she even recognised me. Another time, I met Yinka Shonibare (whom I had worked with at Shape in London several years before) at his exhibition at Brent Sikkema gallery. It was a little disorientating to see people from London in this way because I felt that I had become an entirely different person in New York. It was like a reminder of a different life.

By now, the lease on my apartment in Union Square was about to expire and this time I wouldn't be renewing it: the future was too unpredictable. However, I intended to come back to New York at the beginning of 2000 to see if I could make a break through with my work then, something that unfortunately had not really materialised so far, despite my best efforts. My real estate agent told me he would find another apartment for me in the same building when I returned, so at least I would be coming back to somewhere familiar.

Before I left New York, I discovered that my efforts at gaining exposure for my work had not been as fruitless as I had first thought. Silverstein Gallery, who'd made a studio visit earlier that year, took five paintings from me on a sale-or-return basis. I was pleased my work would be shown to their clients but, because they were a new gallery, I didn't hold out much hope of a sale. However, it was a way of keeping some work in New York for when I returned – and fewer paintings to ship back to London.

Two of my friends from college helped pack my paintings. We took the bigger paintings off the stretchers and rolled the canvases up around cardboard tubes, then covered them in bubble wrap and brown wrapping paper. The smaller paintings were packed in boxes. It was a long and complicated process. When everything was complete, we headed down to the main post office in midtown to despatch the paintings, crossing Fifth Avenue and a Gay Pride march along the way. It seemed rather incongruous to be going about our mundane business in the midst of such joyful celebrations.

I said goodbye to Dad when he and my stepmother visited, a few weeks before I returned to London. We spent one last day together in Manhattan.

The future now seemed uncertain; I no longer knew where I belonged. I would have liked to have stayed in the States, but could live more cheaply in London, and the studio space there was much more suitable. London was by far the more practical option, and I had more connections in the art world there too, yet I knew I would miss New York. My lifestyle in New York was far more exciting than in London, and I was reluctant to give that up. However, at the end of July, I was on a flight back to Heathrow – but not quite defeated. I could still see options ahead.

I remained in London for the next six months. My life was essentially the same: as always, it revolved around painting. That summer, I returned to my studio at Carpenters Road, where most of my colleagues still worked. I fitted back into my old environment very easily, yet I felt like a different artist from the one I had been before. I found that I worked with far more confidence and purpose. I enjoyed having a big studio to myself after the tiny studios I had worked in in New York and was once again able to paint on a large scale without the restrictions imposed by my surroundings. It felt rather indulgent to have so much space.

In September, I contacted Deutsche Bank, following their interest in my work at the Blue Gallery. They asked me to bring my portfolio into their headquarters for a meeting with the curators and selected three pieces to show the purchasing committee. Much to my surprise, all three pieces were subsequently bought for the collection. This was the first major collection I had sold work to. It was a promising start for a new graduate, which is what I felt like. I no longer felt like a mid-career artist. It was as if I were right back at the beginning of my career. However, my painting was going well.

There were certainly far fewer distractions in London than in New York. I made several pieces that I was exceptionally pleased with. I continued to layer oil and acrylic as I had done in New York and started to use metallic paint to add to the mix, which gave my new paintings a shimmering presence. *Blue* and *Strange Attractor,* each measuring 152 x 183 centimetres, were the first large-scale paintings I had made in three years. I did not know if the technique of layering oil and acrylic would work

Untitled. 1998. Acrylic, beeswax and ink on paper. 13.5 x 13.5 cm
Deutsche Bank Collection

Untitled II. 1998. Acrylic, beeswax and ink on paper. 13.5 x 13.5 cm
Deutsche Bank Collection

Untitled III. 1998. Acrylic, beeswax and ink on paper. 13.5 x 13.5 cm
Deutsche Bank Collection

on a large scale (having only made smaller paintings this way), but it was just as effective on an expanded field. Although I was not completely in control of the process, by now I knew how to use the materials. Of course, there were many variables that were outside my control, but chance had by now become part of the process.

At the end of December 1999, in preparation for my return to New York, I arranged to sub-let my studio to Simon Morley, an artist I had met through working on gallery education programmes. Surprisingly, Simon told me he had one of my postcards pinned to his studio wall that he had bought some years ago at the Serpentine Gallery bookshop. I was pleased that he would now have an opportunity to paint in my studio.

I had first moved to Carpenters Road 10 years earlier. It was now the end of an era: another decade had passed and we were on the verge of a new millennium. After six months in London, I was ready to spend another six months in New York. Living and working between London and New York had by now become a way of life.

Chapter Ten | **Millennium**

The turn of the millennium is a night many remember. It is a time of reflection and for thinking about what the future might hold. We heard that a millennium bug was going to hit the world; that it would crash computers and shut down the electricity grid; that planes would fall from the sky. But none of those things happened. In fact, the transition from one century to the next passed smoothly, despite Nostradamus' predictions.

As a child, I always wondered where I'd be that night. On 31 December 1999, I was in London and had arranged to celebrate the occasion with friends.

New Year's Eve at the turn of the millennium was eagerly anticipated. Everyone knew it would be extraordinary and most people wanted to be out with a crowd on such a night. The centre of town was a car-free zone on New Year's Eve so we had to use public transport to get around – something I rarely do in London. We took the train to central London and set off for the funfair on the Mall, outside Buckingham Palace, with a huge crowd of revellers. Because there were no cars on the roads, we walked in the middle of the streets as if we owned them. For one night, it felt like we were reclaiming the streets.

After a few hours, we headed towards Tower Bridge to find a place to watch the fireworks that were due to kick off at midnight – travelling by underground with a considerable amount of difficulty. Green Park was the nearest tube stop and we had to ask people to help carry my wheelchair down to the platform, there being no lift or escalators, but that was soon forgotten once we reached our destination. We sat by the parapets of the Tower of London with lots of other excited people, waiting for the celebrations to begin. Not everyone had been able to get into Trafalgar Square where the New Year's festivities are traditionally held, so people

gathered in several other areas around town and lined the river to watch the fireworks. We were expecting to see a 'river of fire', which would set the water alight.

At Tower Hill, we waited for midnight. The Tower of London was a perfect place to celebrate the beginning of a new millennium, carrying with it all the history of the old. At the stroke of midnight, the fireworks began. It was the sense of anticipation and occasion that made it so extraordinary. Nothing could beat the extravagance of the 4 July display I'd seen earlier in the year in New York, but the millennium celebrations came a close second (despite the 'river of fire' somehow failing to materialise). We drank cava from paper cups to toast the new millennium. Just after midnight, in the early hours of the New Year, when I was asked about my plans for the year 2000, I was able to say that the next day I would be on a plane to New York. I could not imagine better plans for the New Year or a better start to the new millennium.

We left Tower Bridge and made our way back to Liverpool Street station. As the crowd began to disperse, everyone around us headed towards the station, herded together like a scene from the film *Metropolis*, shuffling one step at a time through the narrow streets. On the train home, I delighted in the thought that another adventure lay before me. I never knew what the future held for me in New York. It was always a place of uncertainty.

By late afternoon on New Year's Day, I had finished packing and had everything ready to travel for the next day. Will met me at JFK airport upon my arrival, on his way back to Manhattan from Long Island where he'd spent the night. A snowstorm was forecast which had not yet hit New York, although the snow was already piled a foot high on the sidewalks. I'd been away from Manhattan for six months, where, of course, things had changed in my absence, but it didn't seem that long.

In New York, my new apartment was in the same building I'd lived in before – but this time on the seventh floor. We drove over to get the keys from the real estate agent on our way to Union Square. The apartment was strangely familiar, being so similar to my first. It was the same size but in slightly better condition – if a little more expensive. I had never lived as high up as the seventh floor; the light was extraordinary and it felt as

Eclipse. 2000. Oil and acrylic on canvas. 50 x 45 cm

though I were living among the clouds. In London, I had found a tenant for my flat through an agency so I was now receiving a good rent for it which might make things a little easier financially for me in the coming months. I could only hope so.

People in New York had noticed my absence while I'd been away (and not just my friends). I was surprised that people in my neighbourhood, whom I had never even met, would comment that they hadn't seen me for a while and ask where I'd been. It made me feel like New York was my real home and London just a place to visit.

On my first Saturday evening back in town, I went to the opening of an exhibition at Feature Gallery in Chelsea, which was showing paintings by one of the students who had been in the year above me at Parsons. I'd met him on Union Square the day before and he had invited me to his private view. We had a chance to chat briefly at the gallery before I left. He was still living and working in New York three years after leaving college, which was encouraging for someone like me, who wanted to stay as long as I could.

The following days were spent catching up with friends, meeting up over dinner and drinks and visits to the movies. One of the first things I did was to go out to Walmart and buy a television in the January sales. I decided I had to have a television in New York in the 21st century.

Once I'd had a chance to settle into my new apartment, and recover from the inevitable jet lag, I started to search for a studio to work in, scanning the *Village Voice* each week to find somewhere suitable. I looked at several studios – some were on long leases, others were too expensive, inaccessible, or too far away from where I lived. I would only be staying in New York until 1 July so had to find somewhere quickly. One of the studios I looked at was in an apartment on the Lower East Side, in the building where Allen Ginsberg had lived. This would have suited me perfectly, being an ideal location and within easy distance of Union Square. I signed a provisional contract on the studio and thought I had secured it, but the landlady changed her mind at the last minute and I was left disappointed.

Eventually, I found a studio in the Garment District, on the west side of Manhattan. I signed a lease, which didn't tie me to a fixed term and allowed me to give only a month's notice. The journey to the studio from Union

Square involved two bus rides, which would no doubt have been a simple journey by subway. I had to catch the bus in Chelsea then take another bus along the West Side Highway to Ninth Avenue. I quite enjoyed the journey anyway: I had no deadlines to meet.

My studio was in a tall, rather grand, art deco office block, with a whole bank of lifts, and floors containing various other businesses. My landlady had leased one of the floors and converted it into artists' studios. She didn't live on the premises but had an office there. It was also home to a whole tribe of cats. There were several artists working there – including one of the MFA sculpture students from Parsons.

Though small, perhaps only 20 square metres, my new studio at least had its own door and was self-contained rather than open-plan – a big improvement on my previous two studios in New York. There were two windows which looked across the street onto a photographer's studio. We could see into each other's spaces. Fortunately, he had blackout blinds which were often closed, but even so I could see the flashes from his camera which looked like bolts of lightning.

On my way to work each day, I passed through an area on Ninth Avenue that consisted largely of wholesale fabric and clothes shops. The journey from the bus stop to the studio became a preliminary ritual to painting. In the busy Garment District, people ran through the streets with racks of clothes. Trucks waited by the side of the road ready to load or unload their goods. I hated the way the drivers looked at me as I passed them on the streets, and I would often cross the road to try to avoid their stares. The whole area buzzed with activity. A shop that sold and manufactured buttons was directly across the street from my studio. Other shops sold zips, bolts of fabrics, lace, felt, velvet and various accessories – the area was primarily a centre for clothing manufacturers. Many of the shops displayed signs that read 'wholesale only' (written in Spanish) in their windows. The people who worked in the deli next to my studio spoke very little English, so a visit there was always an adventure since 'hola' and 'agua' were the only words I spoke in Spanish. The Garment District was like foreign territory to me and I still felt like a tourist in midtown. It seemed quite different from my neighbourhood in Union Square, which was so familiar.

I set about preparing my studio to work in by first repainting the walls and the floor (a familiar ritual) then started to gather art supplies to work with. At the top of my list were wooden stretcher pieces, canvas, paper, acrylic and oil paints and turpentine. The assistants in the art shops I frequented in the East Village had also missed me while I had been in London. Like so many people in my neighbourhood, they asked where I'd been. An artist depends on a wide network of professionals for support – an art supplier, a photographer, framer, someone to deliver paintings – all these are invaluable and often found through the recommendation of other artists. But I think that of all these relationships, the art supplier is one of the most important.

I now had a bigger space to work in than either of my previous studios in New York, so I was at last able to paint on a larger scale. I prepared two 137-centimetre canvases, and several smaller ones, and stretched paper on drawing boards to work on alongside the paintings. I like the solitude of being an artist – or, at least, I've got used to it. I had to sacrifice this when I was at Parsons, though I did my best to make my studio private by putting a curtain up in the entrance to my space: in fact, the painting studios at Parsons looked rather like a shanty town, with fabrics of different colour and design in each studio doorway.

My new studio was the best I ever had in New York and led to a very productive period of work. I made five paintings there as a follow-up to the *Strange Attractor* painting recently completed in London, using metallic paint, acrylic paint and oils. I also made a series of drawings using metallic paint, beeswax and Indian ink. I liked the shininess of the metallic paint and it seemed exciting to make gleaming paintings at the beginning of a new millennium.

This time, though, I had abandoned the idea of trying to get galleries interested in my work while I was in New York, and I decided to concentrate instead on developing my practice. While I know it's not a good idea to hole up in your studio and ignore all the other aspects of being an artist, such as the marketing and networking, which are also essential, I decided to use the short time I had in New York just to paint. I had already discovered that however hard I tried to push my career forward, without a little luck it was just not going to happen.

When it was time to document my new paintings, I asked the photographer to hang a black cloth behind the paintings so the canvases stood out: my paintings had become so minimal they would almost have disappeared against a white ground. I had to black out the windows with bin liners to darken the room in preparation for the photo shoot, which was a very complicated process (almost like preparing an art installation) and a major undertaking. Then, all too soon, it was time to pack everything up and ship the paintings back to London. Once again, with help from colleagues, we took the canvases from their stretchers, rolled them up, then took the boxes to the post office – a lengthy procedure which I had by now grown accustomed to.

I had a flight to London booked for 1 July and had found someone to sub-let my apartment in New York – a young Japanese woman who was a musician. The sub-let was for six months, so I would be able to keep my options open for the future should I decide to renew the lease. I thought I would see how this developed, living between London and New York. I liked the idea of living between two cities but didn't know how long I would be able to keep it up. I already knew the problems that come with having to find studios on a short lease – the time it takes to move in and out of a workspace and then settle to work. It requires a flexible attitude and way of working. As a studio-based artist, this would always present problems for me. Additionally, my health problems meant that I often had limited energy.

My friends in New York were all beginning to develop lives outside of the ones we had shared at college. Some were determined to stay in New York 'to the bitter end'; others had already made plans to move on. I felt as if I were in a kind of limbo, neither in one place nor the other.

Back in London, I was able to return to my old studio at Carpenters Road and continue painting straight away – trying to keep the momentum going between the work I was doing in London and the work I was doing in New York. Somehow it felt important, as if I were on the verge of achieving something in my painting. So far, I was making steady progress, and this did not seem disrupted by living and working between two countries, but I knew this was not something I could continue indefinitely.

Apart from maintaining my studio practice in London, I had a deadline to meet for a grant application to the Adolph and Esther Gottlieb Foundation. The application was in the form of a three-page narrative, outlining the trajectory of my career over a period of 20 years as a mature, creative painter. Actually, it was a very useful exercise that made me aware of how much my work had progressed in that time. I thought I had a good chance of getting the award as I had already applied the previous year and my application had been highly commended. This was a good time to concentrate on the application.

In November, I had a studio visit from one of the directors at the Blue Gallery, who invited me to exhibit some of my paintings at their new gallery in Shoreditch, east London, the following year. Because I'd had no offers of exhibitions in New York for the future, I began to focus my long-term plans on exhibiting in London. I felt somewhat defeated by my attempts to succeed as an artist in New York. It seemed that it just wasn't the right place or time for me, but I still hoped things might work out eventually if I concentrated my energies in that direction.

At the beginning of 2001, I returned to the United States for another six months, not knowing what lay ahead but still excited and full of anticipation. At least I had an apartment to go back to. I was just happy to be back in New York and ready to start painting again. As long as I continued to paint, did it really matter where I lived?

I was lucky that I still had artist friends in New York who came to visit and whom I could spend time with. But I knew that some of the students from our group had already left town. I knew that one of the students had started a family and others had moved out to Brooklyn and beyond.

This time, I decided I would try to paint in my apartment rather than look for a separate studio – I didn't have the money to rent a separate workspace anyway. The light in my apartment was good so it only required a little reorganisation. I set up a table in front of the window and found a place to keep my art materials. Using my apartment as a workspace saved time that would have otherwise been spent looking for a short-lease studio and was a lot cheaper. The working conditions were not ideal but, for a short time, it might just work out.

I had to keep motivated and make the best of my time in Manhattan. I went to the Strand Bookstore and Barnes and Noble on 17th Street to research ideas and find source material for a new project. There, I saw photographs by Walter de Mara of lightning in the desert sky, which inspired me to make drawings about the subject. In one of the bookshops, I bought a book about lightning bolts (although it was for children rather than a scientific journal). I bought paper, beeswax, pen, ink and acrylics at the art shop and set to work.

I found it was perfectly possible to work at home provided I spent a lot of time outside the apartment as well, otherwise it would have felt impossibly claustrophobic. This was not difficult in New York, where it was all too easy to spend time at exhibitions and movies. In London, I found working at home very isolating.

In February, I visited the Armory Show on Chelsea Piers. I'd never been to an art fair before and was somewhat overwhelmed by the sheer quantity of artworks on display and the crowds of people milling around the exhibits. It seemed to be a spectacle, simply a marketplace for the exchange of art and money. I could not imagine my work ever being part of that environment.

In the spring, I met up again with one of my friends who lived in Brooklyn with her partner and new baby. The last time I'd seen her had been in my apartment six months earlier, where, heavily pregnant, she had helped me pack just before I left for London. Now, she had a different life, which didn't revolve around her art or her friends like when we had been students at Parsons. It was lovely to see how contented she was. Soon, she and her partner moved out of Brooklyn to a quieter place in upstate New York to bring up their family.

Several significant things happened that spring. First, I heard in March that my application to the Adolph and Esther Gottlieb Foundation had been successful. It was a great achievement and I was elated. I was one of 10 artists, each awarded an Individual Support Grant of $20,000. There were no stipulations for the grant, apart from an obligation to write a report at the end of the year to describe how the award had been used. I was thrilled to share such good news with my friends and family. I knew the award would make a significant difference over the coming year and the news could not have come at a better time.

That spring, Dad collapsed in his apartment in Connecticut and was taken to hospital. He had suffered from emphysema and diabetes for years. When he was taken ill several years earlier, I had been in London and felt useless, being so far away and unable to see him. This time, I travelled to Connecticut on the train from Grand Central to visit him and was shocked to see how ill he looked. Several of his wife's relatives were there at the hospital, standing around the end of his bed. Dad just stared belligerently in their direction, saying nothing.

The next time I visited him in hospital, a week later, I took the grant cheque I'd recently received from the Gottlieb Foundation to show him, which I knew he would be pleased about. Indeed, he was so happy to hear that I had won an award in recognition of my work that he sat bolt upright in his bed to examine the cheque; I knew then that he still had life left in him.

What Dad feared above all else was being transferred to a convalescent home. He knew that most old folk who enter a convalescent home rarely leave. We all thought this would be the next step because he was barely able to walk and completely unable to look after himself. But Dad insisted on returning home. Fortunately, my stepmother, Irma, nursed him devotedly, but after that health scare he was always fragile. He had a terrible pallor and sometimes suffered hallucinations due to the huge range of medication he took. Although his mobility was greatly restricted and his quality of life poor, Dad survived to live a further five years in his own home.

I had an unconventional family life, far from being a nuclear family. Both my mother and father were married three times. I am sure this influenced my views on marriage. In any case, I married late in life, at the age of 48.

At the beginning of 2001, I started to date a New Yorker who lived only a few blocks from me in the East Village. We went to movies and bars, to diners and restaurants, to Coney Island to see the aquarium – but most often we enjoyed simple things like walking around town, visiting the botanical gardens, or spending time in Central Park.

One weekend in June, we made a trip to Philadelphia to see Duchamp's *The Bride stripped Bare by her Bachelors, Even* (also known as *The Large Glass*) at the Philadelphia Museum. It was far too delicate a piece to be

moved out of the museum, so this was the only place for it to be seen (though the Tate has a full-size reconstruction of the piece by Richard Hamilton). We explored the old town and walked along the docks to look at the ships, we were glad when it was time to board the train back to New York, both agreeing that there was no other place to be, practically kissing the ground on our return to Grand Central Station.

Ours was not a great romance, but, that summer, Donald proposed and, for some reason, I agreed to marry him. I now say that I must have been drunk or on drugs at the time. He gave me his mother's ring. I was surprised how quickly things had developed between us. I didn't see how a marriage could possibly work between us, living in two different countries, but it would have to be unconventional and that I didn't mind.

We planned to marry when I next returned to New York, so I did not renew the lease on my Union Square apartment. The next time I came back to the States, we would need a bigger apartment. I am not sure if I have commitment issues but the very words 'married life' sent a chill through me.

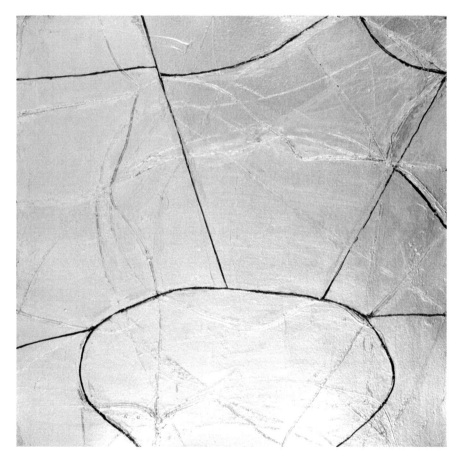

Platinum. 2001. Acrylic, beeswax and ink on paper. 30 x 30 cm

Chapter Eleven | **Falling Slowly**

By now, I was beginning to feel torn between London and New York. It was, as always, with a great deal of regret that I left New York that summer. I wished I could have stayed in the States permanently, but I had already remained in New York far longer than I should have after college, trying to make a breakthrough in my career – a breakthrough that didn't come. Now I had to pick up my life again in London. With the support of the award from the Gottlieb Foundation behind me, the timing was right to move forward.

In London, I had practical things to attend to: I was moving into a new flat in Stratford, east London. In addition, I heard from Acme that our studios at Carpenters Road were due to close within the next few months and all the artists would have to move out. My life was in flux but it was a glorious English summer and for that I was thankful.

First, I needed to find somewhere else to work. It is difficult being a studio-based artist. I am not sure that moving studios as often as I had in the last few years had been productive. It had dissipated my energy, was stressful and time-consuming. The experience of working as an artist in New York had been invaluable but I now felt that I needed to spend at least a year in one place to develop my practice. The continual stops and starts in my working life had been disruptive, and I needed to capitalise on the ideas I had stored up but had not yet had time to explore.

I felt a little sad leaving the studios at Carpenters Road where I had spent so many years (eventually the site would make way for the Olympic Aquatics Centre). As I had first taken a studio there 12 years ago, it was quite a task to clear my space. And with so many artists all looking for new studios at the same time, it was going to be difficult to find somewhere else to work.

I signed up on the waiting list with Acme and with Space Studios and would just have to wait for another studio to become available. Meanwhile, I had to find somewhere else to store my paintings. The studio manager at Space offered me temporary storage for my paintings in Hackney which at least solved one of my immediate problems until I was able to find somewhere else.

Yvonne, who I had originally shared my studio with, came back to sort through her paintings in the storage area in preparation for moving out. Most of the artists were looking at our enforced move as an opportunity to decide which of their work to discard and which to keep. Acme provided several big skips in the car park at the back of the studios for rubbish and soon these were overflowing with discarded artwork.

I asked Yvonne to help me look through my paintings. Sometimes, when I was faced with a painting I was unable to make a decision about, she would say: 'This one might not be as good as you think – have another look at it tomorrow'. I have always been meticulous about documenting my paintings, even though I am not in a position to keep every piece I make, so at least I have a comprehensive record of the work. I was lucky that Yvonne had a good eye and I respected her judgement – she was senior lecturer at Birmingham University. Like most artists, I did not have enough space to keep everything that had accumulated in my studio, with more than 60 paintings in stock.

I discarded many paintings, consigning them to the skip. Yet that was not the last I heard of these rejects. Some years after I had thrown them out, several of the paintings resurfaced. Someone had gone through the skips in the car park and salvaged a pile of paintings (including several of mine), then sold these on to a house clearance agent. Two people contacted me through my website many years later to tell me they had bought some of my paintings in this way. Another person was given one of my paintings as a gift, which came indirectly from the same source. I had thought these paintings had been destroyed. It is odd how paintings seem to have a life of their own once they leave an artist's studio and there is no knowing where they will find a home.

Sometimes a painting will change hands many times in the course

of its life. Despite my best efforts to discard some of my early paintings, they are still in the world. I have learned from this experience. Other more experienced artists at Carpenters Road, such as Fiona Rae, made sure that the work they wanted to leave behind was completely destroyed before putting it into the skips. Now I always cut up any canvases I wish to discard before binning them.

At the beginning of August, when it was finally time to leave Carpenters Road, I stored my paintings in Hackney until I had a new studio to move to. Before long, Acme offered me a studio at Copperfield Road in Bow, east London, on the third floor of a four-storey building. I moved there at the beginning of September. The studios in that building were more like offices than industrial spaces, with lower ceilings and they even had central heating which was a real luxury. I had visited a friend there at an open studio day several years earlier, so I knew the building and knew that it was in a convenient location.

Studio portrait. 2001. Acme studios, Copperfield Road, Bow, London

My new studio was long and narrow, with two big windows on one side. I could see Regent's Canal and the canal lock from my window. With some of the money from my Gottlieb Foundation grant, I had a sink installed and storage racks built. Although I was told when I first moved into the studio that it was a short-term lease, it still needed to be somewhere that would be easy for me to use.

It is always rather disorientating moving to a new studio, but often exciting as well. At first, the environment seems alien, but gradually one acclimatises to the surroundings and the studio becomes a second home. My work was developing well too. Just before I left my studio at Carpenters Road, I made a breakthrough in my painting. Like all good discoveries, it was by pure chance.

In the *Strange Attractor* paintings I had been working on up to that point, the trail of the brush mark would almost disappear among the accumulated layers of paint. Yet, when I hung one of my unfinished paintings at the end of the long studio and looked at it from the other end, I saw something that looked rather like a horizon at the top of the canvas where I had pulled the brush. So, I decided to keep this mark in the painting rather than allowing it to be lost to subsequent layers. This completely changed the space in the work.

The first paintings I made in my new studio at Copperfield Road explored that idea. I also changed my medium and began to use acrylic paint on its own, rather than the mix of oil and acrylic that I had been using in recent years. By changing the materials I worked with, the surface also changed.

I exhibited in two group shows that year. The first was a summer show at the Blue Gallery, which had recently relocated to Shoreditch from Chelsea; the second was in an Acme open studios event at Copperfield Road. It was the first and only time I exhibited in the open studios there and it was an opportunity to meet some of the other artists in the building where I had slowly become part of the community.

I was in London at the time of the World Trade Center attack. The events of 9/11 had an enormous impact on me. Whether I would have

felt the same had I not lived in New York, I don't know. I was at home on the afternoon of 11 September, when I heard of the terrorist attacks. One of my sisters phoned to tell me to watch the news on the television and, when I did, I could hardly comprehend what was happening. The news channel showed the planes crashing into the towers, again and again, in slow motion.

I tried desperately to contact my friends in New York, hoping against hope that none of them had been in the wrong place at the wrong time, but the phone lines were down. I had been to the World Trade Towers several times. When I'd been in New York looking for a studio, I had applied to the 'Windows on the World' residency at the top of the Trade Towers and had visited the studios there on an open day. Fortunately, I was not selected for the placement: I heard that one of the resident artists who had been in his studio on the morning of the attack died there.

On the evening of 9/11, after several anxious hours when the phone lines were down and no calls to the States were getting through, I received an email assuring me everyone was okay. I had only left New York a few months earlier. I might well have decided to stay. The days after the attack were full of fear and uncertainty for everybody. Many of my friends lived downtown, so their lives were disrupted more than most.

The day after the attack was equally ominous on both sides of the Atlantic. In London, it was eerily quiet on the roads and on public transport, with many people staying at home, fearing a similar attack in the UK. I went to the studio because I didn't want to succumb to the media panic. But, like everyone else, I was looking anxiously at every low-flying plane for days after and sleeping with the radio on so as not to miss any developments. The country was on high terrorist alert and we got used to living with that anxiety over the coming months.

In November, the day before Thanksgiving, I had an outpatient appointment at the Middlesex Hospital. Over the last year or two, I had begun to feel some discomfort with my back, and after an X-ray and examination the consultant confirmed that my spine had deteriorated since my last check-up. I had thought that my spinal fusion operation in 1984 would last a lifetime, not realising that such procedures usually

need to be revised at a later date. The consultant asked me to come to the hospital again the following year for a further assessment. I would know then whether he thought another operation would be advisable.

In the meantime, I continued my life with painting at the centre of it – although I often felt that half of me was still in New York. I met up with old friends in London to go to movies and exhibitions, eating out and doing exactly the same things I would do in New York, but everything was different.

I sold a few paintings that year and several galleries made studio visits to see my work, which were small triumphs. At the same time, I made two applications for studio placements in New York: one to the Marie Walshe studio programme and the other to the Elizabeth Foundation studio programme. I was still hoping that I might be able to work there again in the future, but I wanted to be able to spend longer than the six months that had recently become my routine. Unfortunately, neither of these applications was successful and I was reluctant to go through another process of finding a studio through a private landlord. Neither of the two studios I'd had after Parsons had been as good as my studio in London: they were both smaller yet cost twice as much. I still wasn't sure where my future lay. In any case I would return to New York in 2002 and would have to work without a studio again if that was the only way forward.

That autumn, Anne, who had shared my studio at Carpenters Road, invited me to contribute to a limited edition publication she was producing (*Fash N Riot*). I made copies of two of my paintings from the recent *Strange Attractor* series and pasted them on to an A4 sheet of paper, then I made 1,000 copies of my page for the publication. Forty-five artists contributed to the first edition, including Melanie Manchot and Jessica Voorsanger. Many of the artists met for the launch at the Golden Heart in Spitalfields, an East End pub frequented by local artists. Anne had recently graduated from the Royal College of Art and I'd last seen her when she visited me in New York in 1997. Much had happened since then.

I was pleased with the development of my work over the course of the winter and particularly with my new series of paintings, *'Falling Slowly'*.

In these works, I restricted my palette to grey or white, continuing to use metallic paints (steel, silver, copper and titanium acrylics). The title of the series referred to the liquidity of paint and the action of gravity, but also referred indirectly to the events of 9/11. I also made a series of works on paper using metallic paint, Indian ink and beeswax that I felt were equally successful and were a continuation of the series I had made in New York.

However, in my new studio at Copperfield Road, there were problems with access. My studio was on the third floor and the lift was sometimes unreliable or out of order. So far, I had never been trapped on the third floor, but it made me nervous to think what might happen if I were. My previous studio in London had been on the ground floor, which suited me better. There are often problems with access for a wheelchair-user if a building has only one lift (there wasn't a goods lift at Copperfield Road) and it is something I am always wary of. Another practical consideration that made the studio far from ideal was that the lift was extremely small so when my large paintings were brought in and out of the studio they had to be carried up and down the stairs, which was rather awkward.

In the autumn, I asked Acme if there were any other studios that might be more suitable for me, despite being reluctant to move again. As luck would have it, a ground-floor studio had recently become available in another Acme building, the converted Fire Station in Bromley-by-Bow, a building that was nearly 100 years old, in an industrial area of east London, near the Olympic site. It was a square room, nearly 60 square metres, with excellent natural light, one wall of windows and a skylight. It would be possible to park my car right outside the studio too, which would be extremely convenient. One disadvantage was that the studio didn't have any heating, but it did have its own sink and I could easily have storage racks built.

Twelve artists lived upstairs in live/work spaces and there were six studios on the ground floor for non-resident artists. I asked Acme if they would keep the studio for me until the spring, which they agreed – they offered it to another artist on a short-term lease in the meantime. It was difficult for me to make plans for the future at that point.

Before I left London, I had another appointment with my consultant at the Middlesex Hospital, who advised me that he could correct my spine in a further operation if I wished to proceed. But first, I had to consider how I could fit this into my life and weigh up the advantages and disadvantages of having the surgery. I had planned to return to London in 2003, so put my decision on hold for a little longer. I knew I would need to address the matter before too long and it would be a very hard decision to make. While there was no obligation to undergo surgery, if it were to improve my life for the future and stop further deterioration, it was something I should seriously consider over the coming months.

At the end of September 2002, I was due to fly out to New York again. I had only recently returned from spending a week there. Life was getting complicated. When it was time for me to leave London, I packed all my paintings up in the studio at Copperfield Road and put them once again into storage – it seemed I was always packing and unpacking paintings these days. My base was now in London: at least there I had a flat and a studio to come back to. This time, when I went out to New York, I didn't have anywhere to live or work. But it was exciting, living between two countries, despite the many practical issues that came with it.

Back in New York, Donald and I spent the first 10 days holed up together in a midtown hotel until we could find somewhere to live. He would set off for his office in the morning and I would spend the day reading or go to the movies to pass the time. Next, we took a sub-let on West 54th Street, near Carnegie Hall, where we stayed for a further 10 days. Our landlord Robert was a professional musician. He had a grand piano and a whole wall of books in his apartment, as well as piles of sheet music and paintings furnishing the space.

After a couple of weeks, we moved to another sub-let on West 55th Street in Hell's Kitchen, just around the corner, which was far more impersonal. There was just time for a visit to Connecticut to see my dad and stepmother before we got married in October at City Hall, with one of my art school friends as the only witness. A very low-key wedding.

The night before our wedding, I cried. I had a premonition that things would not work out well.

Early in November, Donald and I moved into our own apartment on Christopher Street in Greenwich Village, a fantastic neighbourhood. Arriving by taxi, the doorman came out to open the door of the cab for us and helped carry our bags inside, welcoming us to our new home. The doorman, dressed in a smart uniform with hat and gloves, looked like someone from a scene in a 1930s movie. I was so relieved that we had at last found somewhere permanent to live and it was everything I hoped it would be – a lovely apartment in a cool building.

I enjoyed living in Greenwich Village. In the 1960s it had been the bohemian part of Manhattan: Dylan Thomas in the White Horse Tavern, Bob Dylan in the jazz clubs. Now, like most of downtown, it had become gentrified, but still retained a lot of its original charm. I was a regular at the coffee shop at the end of our road and the diner around the corner, and enjoyed living among Greenwich Village's tree-lined avenues, so close to the river and Washington Square Park. From our apartment, we could see the Empire State Building lit up at night and several other landmarks. It was perfect. Now, settled at last, I was able to start work again.

I bought supplies from the art shop and started to paint, glad to be able to be productive again. So far, between moving apartments, I felt as though I had accomplished very little. I used one end of our apartment as a studio and painted on paper while sitting on the floor. One of the pieces I made in the apartment was my *Union Square* painting – based on the hexagon-shaped paving stones of the park in Union Square. Another painting I made on Christopher Street was *Permafrost*, using acrylic, beeswax and Indian ink.

Before the winter set in, I often spent time in nearby Washington Square Park and at the piers in Chelsea (two locations I was already very familiar with). Both were close to Christopher Street. The galleries downtown, the art house cinemas, the bars and coffee shops I knew, were all once again within easy reach. While it had been interesting to live midtown for a while and to appreciate how different that part of Manhattan is, I was glad to be back on familiar territory.

Along with every other tourist in the city, it was now obligatory to visit Ground Zero to see the remains of the World Trade Center – the impact of the devastated site cannot be overestimated. In fact, after 9/11, many things had changed in the city. The spirit of optimism, which I had always associated with New York, seemed to have dissipated in the wake of the terrorist attack. People were wary, scared, suspicious.

On Christmas Eve, we took the train from Grand Central to Connecticut, to spend the day with my dad and stepmother, and then back to Christopher Street later that same evening. The train was packed with people visiting their families for the holidays. Christmas Day was the second Christmas we'd spent together and our first as a married couple. There was a snowstorm in the afternoon and, of course, we had to go out on to Christopher Street to watch as it became a white Christmas.

In the New Year, as the build up to military action in Iraq became inevitable, I watched the news each evening, hoping against hope that Hans Blick would be given time to ascertain the existence of weapons of mass destruction before the point of no return. And then there was no hope. The night of 'Shock and Awe', when the first military offensive was launched, is one that I shall always remember – curled up on the futon, watching the television screen as the first missiles were launched. I would not have liked to be alone that evening.

As spring returned and it was nearly time for me to leave New York once again, I made the most of my last few weeks in New York. I visited my dad and stepmother in Connecticut before I left, but this time I knew it might well be the last time I saw them. I was about to return to London and did not know when I would be back (Donald and I couldn't seem to agree about where we wanted to live or even if we still wanted to live together). My dad was in poor health, but at least I knew he was loved and cared for by his wife.

I left New York just before Easter in 2003. This time, despite being married, I had no definite plans to return. Whenever I had left there before, it had always been with the promise to return. Now, with my health problems to deal with, and a new studio to move to in London, I did not know what the future would hold.

Once I had made up my mind to return to London on a more permanent basis, things became a little easier. It had been rather unsettling, although certainly exciting, living between two countries for so long, but moving apartment three times in the last six months had been exhausting. I needed a more settled existence in my personal life and in my working life too so my decision to return to London seemed sensible.

My marriage was unfortunately not one of my better decisions. It was a huge mistake and a bitter disappointment. We were divorced four years after we married, although our marriage had broken down much earlier. I discovered that it was far easier to get married than to get divorced – particularly as Donald refused to sign the divorce papers. Our marriage did not end amicably, but it was certainly a lesson learned and time to move on.

In 2003, back in London, I got ready to start work in my new studio at the Fire Station, with the help of friends who loaded my paintings into a van and helped me redecorate, using extension poles and rollers to reach the top of the walls. Painting a new workspace seems to extirpate the previous occupants. It was quite a task, but the studio looked clean and welcoming once the job was complete. It was a studio where I felt I could make good progress.

The atmosphere at the Fire Station was different from any of the Acme studios where I'd worked before. It was a mixed-use building, both residential and non-residential, but the non-resident artists on the ground floor and the resident artists on the upper floors rarely mixed. I felt quite isolated at first, yet I was at a different point in my life. Now, when I came into my studio each day, I was actually quite glad of the solitude and the fact that there were so few distractions.

Events moved swiftly that summer. Within two weeks of returning to London, I was contacted by the owner of a new gallery in Shoreditch, who had found my work online. After a studio visit to see my paintings, he invited me to take part in a group show at his gallery. The summer show at the Woolff Gallery opened in the middle of July, after which I was offered a further exhibition in a four-person show that autumn. Also that summer, I sold a large painting to a private collector in London through

a consultant. In September, three of my *Lightning* pieces (works on paper that I'd made in New York) were sold through the group exhibition at the Woolff Gallery.

My initial contact with the gallery director of those shows came through the internet. In the last few years, with widespread use of the computer, the possibilities of seeing an artist's work online had opened it up to a much wider audience. The web was another way of marketing paintings and of making the work more visible. The downside of all this was that artists had to spend more time maintaining an online presence. Some of my friends already had their own websites but I did not launch my own site until 2007. I'd had my first lesson in computer science many years earlier when I'd worked at an office. Although I had written my papers at college on the computer, it was only when I bought my first laptop in the year 2000 that I really started using email. The computer had already become an integral part of an artist's working life by the start of the new millennium and I was still struggling to keep up. I knew I had to become computer literate.

I felt quite optimistic about developments in my work, if not in my personal life. I just had to learn to put those disappointments aside. That summer, I went to visit Eve Thubron in Sussex. She had been such an important part of my life when I was a child, and I have never forgotten her kindness and warmth towards me. I had last seen her in the autumn of 2002. Eve was now in her nineties, but still optimistic and bright. Updating her on the state of my marriage (which she had originally been very excited about), she was neither disappointed nor surprised, just pragmatic. Eve was far more enthusiastic about the progress in my career. The importance of having a project was something she had always subscribed to.

Chapter Twelve | **Further Spinal Surgery**

At the end of 2003, I had an appointment with my consultant at the Royal National Orthopaedic Hospital. I had already made up my mind to proceed with a revision of my spinal fusion, having considered all options very carefully over the previous year. I knew that as I grew older I would not want to put my life on hold – as I would have to in the coming months. Also, I doubted whether I would have the fitness required to undergo major surgery if I left it much longer. My condition would continue to deteriorate and I might not then have the option to correct it. I was beginning to experience pain and discomfort which was impacting on my daily life. I wanted to deal with the situation so that I would have a better quality of life in the future.

Final tests and X-rays were taken and the operation was scheduled for February 2004. I was warned that the operation could prove life threatening – as I had been warned before my first spinal fusion in 1984. Again, I was determined to go through with it, thinking that the odds of not surviving the surgery were slight – but I did not know just how wrong my assessment of those risks would prove.

I sub-let my studio at the Fire Station for six months, with an option of extending the sub-let if I needed more time to recover. I hoped that I would be well enough to be back at work in the studio by the end of the summer. However, I remembered how long it had taken me after my previous spinal operation to regain my strength and knew it would be slow progress at best.

In February 2004, I was admitted to the Middlesex Hospital in central London, part of University College London. The hospital closed in December 2005 and has since been demolished to make way for luxury flats. This old Victorian building was historic. Set on the original site of the

workhouse that inspired Charles Dickens' novel *Oliver Twist*, the hospital was run-down and desperately in need of modernisation.

I was a patient on the orthopaedic ward, where rows of beds were packed closely together in what is referred to as a Nightingale ward. If anything, it looked worse than the ward I had been in at Stanmore 20 years earlier. The wards were short-staffed and the lack of personal attention was obvious. The conditions and the facilities at the hospital were poor. The nursing was impersonal. Nurses would spend an inordinate amount of time on the computers, more like technicians than hands-on carers, and the cleanliness of the ward left much to be desired.

My consultant, Mr Etherington, had an interim placement at the Royal National Orthopaedic Hospital. I had seen him several times as an outpatient. He was an Australian with a distinguished reputation who had replaced Mr Edgar, the orthopaedic specialist who had been my surgeon 20 years earlier. Mr Etherington had a blunt approach, but I trusted his outspoken assessment of my condition.

In order to correct my spine, he would have to completely remove the metalwork from my previous operation. Bone had, over the past 20 years, grown around its support and skilful surgery would be needed to disengage the metalwork without damaging the nerves. Then, he would construct a new support system for the spinal column, using a fine titanium rod and screws. Mr Etherington hoped to complete the whole of the operation in one session but, if necessary, it would have to be completed in two stages. I would not need to wear a plaster cast or orthopaedic corset after the operation this time, as I'd had to after my previous spinal fusion, which was a relief. I could expect to be in hospital for four to six weeks, which was rather shorter than the three months I had spent at Stanmore after my first spinal operation in 1984.

I was taken to the operating theatre early on the morning of 12 February. One of my sisters waited at the hospital during the operation and would be there at my bedside in the recovery room immediately afterwards. I told my family before I was admitted to the hospital that I was scared of this operation. I knew the risks and always thought I would come through it, but I was scared of the pain and what it would entail.

The operation went badly. It lasted 14 hours and I nearly died on the operating table. I started to haemorrhage towards the end of the operation and the surgeon was unable to stem the bleeding: I lost more than eight litres of blood. My sister, who was at the hospital waiting for me to leave the operating theatre, became increasingly anxious as the hours drew on. The surgeon fought to save my life and was eventually able to bring the situation under control.

Finally, back in the recovery room and on a life-support machine, I briefly regained consciousness to find panic around me. One of my arms was swelling grotesquely and I was on a ventilator because one of my lungs had collapsed during surgery. Mr Etherington had been called and I was about to be wheeled back to the operating theatre to have the arm amputated, according to my sister, because the swelling had spread so rapidly that it had turned black. The nurse responsible for my care admitted later that fatigue had caused her to make an error in administering medication via the intravenous tube. I narrowly avoided losing a limb as a result of such negligence and luckily my sister's close observation of my condition and subsequent intervention prevented the incident from escalating.

My life hung in the balance for several days. The surgeon had tried to complete the procedure in one operation but this had been impossible because of the haemorrhaging. I would have to go back to the operating theatre for a second time when my condition stabilised. I remained in intensive care for nearly a week, on a life-support machine most of the time.

On the ventilator, I could not speak and had to write notes if there was anything I needed to communicate. Lying there on the hospital bed, lapsing in and out of consciousness, with tubes coming in and out of my body, I felt real panic. My mind was functioning, but my body seemed about to give way. It was not as though I had lost the will to live, I simply had no control over what happened to me. I had to trust the hospital to keep me alive, and yet I had already witnessed a major error which had nearly caused me to lose an arm.

At first, I didn't feel safe – I thought the nurses might give me the wrong blood type, for example, or that they might switch off the ventilator.

I would be able to observe this but unable to do anything to prevent it. The morphine and the anaesthetic induced hallucinations (apparently quite common in intensive care) and I thought I saw dead bodies all around me, like on a battlefield. I was frightened to close my eyes, thinking I would die if I didn't remain vigilant. My mind played tricks and I lost all sense of time. It was as good a time as any to reflect on my life as I sank deeper into the past. People. Places. Images. Sounds. Things said and done. Decisions made and promises broken. All these unfolded like flashbacks, rewinding through the past and into the present.

The nurses injected medication through a line fitted to the side of my neck (I must have looked like Frankenstein), and I was attached to various machines and monitors that prevented me from moving. A drain on one side of my body drew the fluid from my collapsed lung; another on the other side drained the surgical wound. I was extremely frightened, unable to breathe unaided, to speak or to move. When the doctor eventually withdrew the ventilator, I did not know if my lungs would function. It was a relief to find that when I was taken off the ventilator, I was finally able to breathe unaided.

A friend came to visit me in intensive care, bearing gifts of food she had purchased from the nearby deli. She practically collapsed outside the ward afterwards, slumped in a chair. One of the nurses told me she looked green. Her father had recently undergone bypass surgery and the intensive care unit had been an unfortunate reminder of this.

After being discharged from the intensive care, I returned to the orthopaedic ward. I had to face a further operation in a week's time to complete the spinal fusion. At first, the pain was unbearable. However, I was prescribed morphine which was effective in alleviating it. I knew from previous experience how this drug worked – the short waiting period for the pain relief to kick in and then the time when it becomes less potent, just before the next shot is due. I knew that I had to keep abreast of the pain and not allow it to overwhelm me.

I was frightened by the lack of care in the orthopaedic ward. In the intensive care unit, a specially-trained nurse was assigned to each patient and stood at the foot of the bed the whole time. In the orthopaedic ward,

there was little individual attention given to each patient. There were just not enough staff. I still needed to use oxygen and special breathing equipment several times a day to increase my lung capacity. I worried I might lose my ability to breathe, having so recently regained it.

At first, I was unable to sit up and had to remain lying flat on the bed. The staff did not offer to feed me and often I would go hungry because I did not have the strength or state of mind to ask for help. At mealtimes, the nursing staff would take their break, leaving the auxiliary staff to distribute the meals. They would bring the food to the bed on a tray with a cover on top of the plates (the meals were in any case completely unappetising) then take the tray away again, untouched. My blood count dropped because of lack of nutrition. I was prescribed a special high-protein diet and food replacement drinks by the house doctor. I needed to regain my strength before the next surgical procedure.

I had plenty of time for reflection in the days after the operation – plenty of time to review my past. There was nothing else to do. I tried to read or listen to music, but could not stay alert for long enough. I didn't make friends with any of the other patients on the ward. I noticed that, since my last hospital experience, there was a faster turnover and most patients completed their recuperation at home. Luckily, I had family and friends who visited me during my stay in hospital and this made all the difference to the time I spent there. I cannot imagine how it would have been without their support.

The night before the second part of the operation, Mr Etherington came to the ward and wheeled me in my bed down to the X-ray department so that he would have X-rays to consult the next day. That task is usually done by porters with a nurse accompanying the patient, but no staff were available to help him. My consultant, though, was completely unfazed by this lack of procedure – a cup of coffee in one hand as he pulled my bed along the length of the ward and along the corridors to the X-ray department. He expected me to be as tough as him in the face of such hostile conditions. I knew he was one of a team of surgeons who performed spinal surgery in Third World countries for a charity – he had no time for sympathy or a soft approach. He lacked a bedside manner,

but I got used to his demeanour. If I cried, he would look away and say nothing. Tears had no place here.

I was scared to return to the operating theatre for a second time. This time, both of my sisters were going to wait at the hospital during the operation and be at my bedside when I regained consciousness. My family had not anticipated that they might lose me after my last operation and it came as a shock to realise how close I had been to death. This time the operation went smoothly and lasted only about six hours. The metalwork was replaced with great skill and Mr Etherington made an excellent job of correcting my spine. In fact, the results exceeded expectations.

In the recovery room after my operation, I regained consciousness almost immediately but was in a lot of pain. Usually after an operation there is enough pain control in place for that not to be an issue. Something was wrong. It transpired that the morphine drip had been detached when the porters wheeled me from the operating theatre to the recovery room. The nurse accompanying my bed had taken the drip down from the drip stand when the bed was wheeled into the lift and had forgotten to set it up again before we returned to the recovery room. It was not the best way to regain consciousness. Eventually, I drifted back to sleep as the drugs administered regained control of the pain. From a distance, I heard one of my sisters asking the surgeon if I was going to be alright, to which he curtly replied: 'She's in intensive care, isn't she, so I can't guarantee that'. However, the best thing as far as I was concerned was that this time I was able to breathe unaided and did not have to use a ventilator.

When I was eventually moved back to the ward from the intensive care unit, I was still extremely weak. The staff on the orthopaedic ward began to mobilise me after about a week, at first sitting me up in bed with the aid of pillows and a hoist. I simply had no strength to move myself and hated to be moved because of the pain. I started physiotherapy while I was still in bed on the ward. I found that I became breathless very easily; my lungs were still very weak and I couldn't speak more than a few sentences without stopping halfway to take a breath. It took a while to regain my full lung capacity.

After the first week, I was put into my wheelchair and taken to the physiotherapy department to start an intensive therapy regime. I wasn't

even strong enough to push my own wheelchair at first. I attended the gym twice a day from then on: first learning how to sit up by myself, then to turn over on the bed from side to side unaided, then learning to transfer from my wheelchair and back, doing exercises to increase my muscle strength. At first, the slightest movement was painfully slow and laborious. I was also assigned an occupational therapist who taught me how to wash and dress. I found it difficult to move because it was impossible to bend my back and the slightest movement of my torso was painful.

To add to my misery, a small section of the surgical wound on my spine had become infected with *E. coli* (an infection attributed to poor cleanliness within hospitals). At least it was not MRSA, which would have been far worse. The surgeon asked if I would go back to the operating theatre to have the wound opened and scraped, but I told him I could not go through another general anaesthetic. I cried at the very thought of it and flatly refused.

The only alternative was to prescribe intravenous antibiotics to deal with the infection, for which I would have to go back to the operating theatre to have a PICC line inserted through image monitoring. The line is inserted into a peripheral vein and then advanced through increasingly larger veins towards the heart. Once in place, it is easy to administer intravenous medication on a regular basis. I needed huge doses of antibiotics at regular intervals to fight the infection.

Although I had started my rehabilitation programme well and the occupational therapist and physiotherapists were pleased with my progress, the antibiotics made me nauseous and listless and this impeded my recovery. I knew, though, that the longer I stayed in hospital the worse I would feel, and the greater the possibility of catching a more serious infection such as MRSA or *C. difficile*. As the infection came under control, I gradually began to feel a little better. However, one morning, while waiting to be taken to the physiotherapy department, my PICC line came free and blood haemorrhaged in a great arc from the vein in my arm to a pool on the floor. Fortunately, the ward sister was nearby and staunched the bleeding. It was a relief when the infection finally abated and I was able to concentrate again on regaining my mobility. I knew I had to cope on my own at home, even if it would be with a great deal of difficulty.

The hospital wanted to send me to a rehabilitation unit to continue my recuperation. They did not have space on the orthopaedic ward to allow patients to stay long and my infection had delayed my progress. I knew that if I wanted to be discharged from hospital and go home rather than to the rehab unit, I would at the very least need to be able to move from my wheelchair to my bed on my own using a transfer board. I'd also need to be able to manoeuvre my wheelchair myself and would need to cope with a certain level of personal care. The staff at the hospital thought I was too vulnerable to manage on my own but I was insistent, so the ward sister arranged for social services to provide a care package for me at home and eventually I was discharged from hospital.

When I left hospital, I spent a few days at my younger sister's house in Essex, before returning to live alone in my flat in London, where I would be under the care of the district nurse to tend my wound. A personal carer came in every morning to help me wash and she spent one morning a week doing my shopping and cleaning. I was still using oral morphine and continued to do so for at least a month after I left hospital: it was difficult to withdraw because I had by now developed a dependency on it. I would have been quite happy to take morphine indefinitely because my doctor would have continued to prescribe it on a long-term basis. I was frightened of pain. In hospital, I learned to manage the pain by pre-empting it.

Ultimately, I was just glad to be alive, realising how close I had been to dying. I cannot say that every day was a joy, because at first it was not: it was extremely hard work. A major problem was that I tired very easily and had absolutely no endurance. I had been given a second chance when I could so easily have lost my life. If I had died at 49, I would have felt my life had been cut short. I had been given a chance to do more and an opportunity to achieve greater things.

At home, it was a battle to regain my strength. An occupational therapist taught me everyday tasks like how to get into the bath and make my bed – tasks that seemed disproportionately difficult at that stage in my recovery. A physiotherapist helped with my transfers from my wheelchair to the sofa and the bed, and with exercises to increase the strength of

my arms. I still found it difficult to move. I found that everything required a huge amount of effort and planning.

I had an outpatient appointment with my surgeon in mid-April, only two weeks after leaving hospital. He told me how delighted he was with my progress and encouraged me to regain my independence. I would need to be an outpatient at the Royal National Orthopaedic Hospital for some time, but I was assured that it was extremely unlikely that I would ever have to undergo further spinal surgery.

The care package I received from social services was short-lived and, within a few weeks, I was left to cope on my own. All my energy had to go into taking care of myself. It was a big day for me, the first time I found the courage to leave my flat on my own. It was slow progress. Indeed, the first time I was able to wheel myself to the lift along the long corridor outside my flat was a triumph. As soon as I was able to get out and about again, I started an exercise regime, wheeling myself around Stratford town centre where I lived, for 15 minutes a day, gradually building up my endurance. I must have looked a strange sight, white-faced, stick thin and stiff as a board. Actually, I didn't much care what people thought of me.

The next goal was to start driving my car again. I couldn't do that on morphine so this motivated me to withdraw: first to reduce, then completely stop my dosage. The occupational therapist taught me how to transfer myself in and out of my car and how to lift my wheelchair into the passenger seat beside me. I had managed this before my operation without even thinking about it but I had to regain confidence in my body again. By the beginning of June, I was driving short distances again. I still experienced pain but continued to reduce the amount of pain relief I was taking. For months after, I would always carry painkillers with me wherever I was.

At the beginning of August, I returned to my studio at the Fire Station, a month later than originally planned. I could not paint as easily, being far less mobile, but gradually built up my stamina over time until I was able to spend longer days at the studio over the following weeks as my endurance improved.

I was unable to paint on large stretchers at first, so had to adapt my

working process to my circumstances. At first, I painted on canvas laid out on the floor. I simply poured paint on to the canvas, trying to learn how to control the mark-making. I also made works on paper, a process which I could handle very easily. Then I painted on small stretchers laid flat on the table, trying to accustom myself to the process rather than working on large canvases pinned to the wall as I usually did. At least I was able to continue my practice, although I was not too pleased with the paintings I was making.

I had one slight piece of encouragement in those early days back in the studio. Before I went into hospital at the beginning of the year, I had entered the John Moores Painting Prize competition, and was notified in the spring that my painting had been short-listed for the exhibition. I sent the painting to Liverpool for the final selection by the jury (which included Jarvis Cocker and Callum Innes) but was not too surprised that my work didn't make it through the second selection process because such competitions are often like lotteries. However, it was encouraging to be short-listed at a time when I felt concerned that I might never again be strong enough to paint. I

Studio portrait. 2004. Acme studios, The Fire Station, Bromley by Bow, London

would be physically stronger in the long-term as a result of undergoing the surgery, but knew that I would probably have to write off a year of my life to achieve this. I also worried I might have depleted my physical resources, that I might just burn out, but fortunately this did not happen.

At the end of August, I moved to a new flat in Docklands overlooking the river. It seemed a reward for the difficult period I had endured. The view was an endless source of wonder: the shifting light on the water, sunsets across the river each evening and the constantly changing skyscapes. With time, my health improved and my mobility along with it. Soon, I was able to do most of the things I had been able to do before, just a little more slowly and in a different way. I would never again have the flexibility I had enjoyed before, but my condition had stabilised and, as the pain subsided (as I was assured it would), I began to appreciate the improvement in my health.

As autumn approached, I prepared for another winter in my studio. I needed to get a reliable heating system installed; I wouldn't be able to work in a studio that was damp because of the problems I had experienced with my lungs. The previous winter I had used a small calor gas heater, but this was an inadequate source of heat that did not keep the cold or damp at bay. Fortunately, I received a grant from the Artists' General Benevolent Institution to install an efficient industrial heater in the studio before the cold set in.

By the end of the year, I was able to spend whole days in the studio again. At first, after my seven-month break, all I was able to do (or had the strength to do) was to go from home to studio, work a little, and then return home. It took all my energy to get through the demands of a working day, particularly travelling to and from the studio. Eventually I became more agile and able to continue painting as I had before. Then I was once again able to reclaim my life; to pick up my social life as well as my painting. The future looked promising. Indeed, it was amazing how quickly the bad times passed and how optimistic I now felt – all this in a relatively short space of time – and I was once again able to make plans for the future. At the beginning of the year, everything had looked so different.

Variable. 2005. Acrylic on canvas. 150 x 135 cm

Chapter Thirteen | **Cosmos or Chaos**

The world once again seemed full of possibilities. I was quite sure that the difficult decision I had made to interrupt my life and take time out to have further spinal surgery had been the right decision to make. It felt like I had been given a new lease of life after my near-death experience but I still had a long way to go in gaining recognition for my painting. There are thousands of artists working in London – and very few of them are actually making a living from their art alone.

I realised that the grant I had received from the Adolph and Esther Gottlieb Foundation in New York three years earlier had made a huge difference to my work at a point in my career when I desperately needed investment in my practice. It had been a reward for past efforts as well as an incentive for future success. I now needed to build on the progress I had made and move forward with my career. Therefore, I applied to Arts Council England for a grant to fund a period of research and development in my practice that would buy time. I was delighted when my grant application was approved. It felt like an endorsement of my work and I was sure that winning the award would pay dividends in the future.

So, as the year 2005 began, I was finally able to resume my practice at the level at which I had left it a year earlier – largely due to the support of the Arts Council. I now had the resources to plan a new series of large-scale paintings and at last felt physically capable of making them. In general, the future looked bright. I felt no pressure to seek out exhibition opportunities; I wanted to concentrate instead on developing my painting.

That year, the only two exhibitions where I showed my paintings were in an open studio event at the Fire Station and a charity fundraising event for Cancer Research UK at Christie's. It was enough for me. I resumed my studio routine and was confident that good work would follow.

I also wanted to try to spend more time enjoying myself outside of the studio and have a better social life. When I am working I tend to withdraw into my own world, but while I was so desperately ill in hospital, I made a promise to myself that should I survive the surgery, I would try to enjoy a better life balance. My recent near-death experience had helped me re-assess my priorities. In fact, it seemed that after each of my two major surgical operations (1984 and 2004), there was an enforced pause in my life and an opportunity to begin anew. So, this is exactly what I did. I started to pick up my social life again after a period of enforced immobility.

On 7 July 2005, I had planned to visit the National Gallery after a morning in my studio, and had planned to meet an artist friend at a pub in east London that evening. However, because of the day's extraordinary events, I did neither. I was painting in my studio that morning when one of my sisters phoned to tell me of the terrorist attack in London, the suicide bombing in which 51 people lost their lives. I had been completely unaware of the event, lost in my work and cut off from the world in my studio.

Everyone was shocked by what had happened. We all felt a sense of insecurity for weeks after – as much as we had after 9/11 – and were not entirely surprised by the second terrorist attack that took place on 21 July. But everyone continued to go about their business with great stoicism, something that British people are very good at doing. Not exactly forgetting the danger, but doing their best to continue despite it.

I was by now completely focused on my painting, working hard in the studio now that I had regained my health. Painting is a constant that has always been part of my life, unlike any other relationship I have known.

For my Arts Council project, I extended the range of the series of paintings begun two years earlier, entitling these paintings *Variable* because of the many different factors that played a part in their making. These paintings proved very successful. A measure of their success was that they all sold. Three of the paintings were bought by the French bank *Société Générale* for their new headquarters near Tower Bridge.

I also continued to work on my series of large-scale, landscape-format paintings, now that I was physically capable of painting on such a scale again. The first of this series, an earth-coloured painting called *Stretch*, was bought by a private collector in Washington DC. In addition, a number of my paintings were bought by Lawrence Graham LLP for the law firm's new building on the South Bank (designed by Norman Foster). It was the largest consignment of paintings I had ever sold. Things looked promising. As I had hoped, the Arts Council's investment in my work had enabled me to generate further funding through sales of my paintings and, for a short time, had given me a measure of much needed financial security.

In the summer of 2006, I exhibited at a group show in Smithfield, in a pop-up show that took place in a disused shop. I could see my painting from the road as I drove to the private view and, with so much distance between myself and the painting, I was able to view it afresh. I thought it looked spectacular – and I am not easily impressed by my own paintings.

Despite this success in my work, it turned out to be a sad year. In October, my dad was taken ill and died in hospital in Connecticut soon after. The few times I spoke to him on the phone when he was in hospital, he already sounded lost to the world. Dad's wishes, which he stipulated long before his death, were that he was to be cremated and buried in the cemetery without a priest and without a funeral service or a wake. He did not want a religious ceremony to mark his passage from this world.

My elder sister and I flew out to the States a week after Dad died to spend a little time with my stepmother and to have our own memorial for him at the cemetery. We bought flowers to lay on his grave, the tombstone already in place with his name and the dates of his birth and death inscribed on it. I recited the Lord's Prayer at his graveside in English, while my sister and stepmother alongside me prayed aloud in Polish. Now that both my parents were dead, the world seemed a colder place. It was a moment of reckoning; I had only myself to rely on from now on, cut loose from my roots.

My sister and I spent two days in New York before catching the plane back to London. I hadn't been to New York since early 2004 and then it had been in very different circumstances – I'd been married

Green/Blue. 2006. Acrylic on canvas. 45 x 45 cm

at the time. That person could not have been me, I thought, as I wandered the same streets where I had lived only two years earlier with my husband.

The first night in town I met up with one of my friends from art school, and we went out to dinner, then sat drinking saké at a bar to drown my sorrows. We had lots of news to share, catching up on all that had happened over the past few years. She invited me to a fancy dress party that night (it was Halloween), but I was in no mood to socialise.

There was just time for a visit to the Museum of Modern Art to see the Brice Marden retrospective (where we all thought Marden's earlier monochromes were far better than his recent paintings), before going up to Central Park to meet Will at his apartment and then heading back to the airport.

It was a whirlwind visit to the States, one of great sadness: three days in Connecticut and two days in New York. I was glad to spend a little time with Irma, my stepmother, and that I had been able to see my father's final resting place. However, to see Dad's name inscribed on the tombstone so soon after his death, so deliberate and final, was something of a shock.

My stepmother returned to Poland soon after my father's death and, with her, my links to Connecticut were severed. I think it unlikely I will ever return to the town of my birth and sometimes I wonder if I will ever return to New York. Everything has changed in the years since I left.

Stretch IV. 2006. Acrylic on canvas. 152 x 183 cm

In London, I continued to work steadily in my studio, winning a further award from Arts Council England in 2007 that enabled me to buy art materials and make a series of new paintings. The award also encouraged me to look for exhibition opportunities to show my work. Again, it was wonderful to have such support. Quite apart from the financial investment in my practice which it provided, the grant re-energised my efforts and enabled me to accomplish much more than I could possibly have done otherwise. The endorsement of my work was invaluable and increased my self-esteem and confidence in myself as an artist.

Outside of the studio, there were good times too. In London, I started dating again, thinking that perhaps my last few experiences had been unlucky. I had heard that it often takes a while after a divorce for any relationship to succeed and this proved to be so.

Meanwhile, the progress in my painting continued and I took part in two group exhibitions that year – 'Arts Unwrapped' and 'Art in Mind' – both in east London. 'Arts Unwrapped' was a summer show, an open studio event that encompassed studios and studio groups from all over London. 'Art in Mind' was held in December at a Brick Lane gallery, a vibrant part of east London. This was a mixed painting show that included eight other artists.

After the private view at the gallery, I went back a week later to have another look at the show. I'd hung three small paintings as a triptych and thought they worked well as a group. This encouraged me to continue experimenting in the studio with groups of paintings and with scale – there is always something to be learned from seeing one's work outside of the environment where it was made.

My next show was a solo exhibition at the beginning of 2008 at a law firm in the City. Although a good venue, it was outside the mainstream art circuit. Yet it was the right time for a solo show. It had been 13 years since my last one. Many things had happened in that time: living in New York, health problems, marriage, divorce. It felt like I had been exhibiting consistently, and indeed I had, but these had all been group shows and many successful artists have at least one solo show each

year. I would definitely need to be more proactive in the future, I thought, if I wished to take my career to the next level and achieve a higher profile for my work.

Later in 2008, I was included in two group exhibitions at a gallery called Contemporary Art Projects in Shoreditch. The first of these shows, '00 Nature', included nearly 60 artists; its theme was nature's changing role in the noughties. The second show at Contemporary Art Projects, 'Start Your Collection', was an annual summer exhibition. Both exhibitions were an opportunity to reach a wide audience of artists and collectors, being situated in a busy part of the city.

However, recent events in the financial sector were having wider implications globally and on the art market. The art world was deeply affected by the economic downturn which was rapidly gathering momentum. Galleries were finding it hard to survive at a time when buyers were scarce and many were already closing down. Artists, whose lives are always precarious, were suffering as a result.

I was extremely anxious about the future. I really had thought for a time, perhaps naïvely, that an artist's career could be linear. But I now know very well from experience that this is not so. Prospects of an imminent economic recovery looked unlikely, and there was talk of a depression. In fact, the economic recession of 2008 turned into the longest and deepest downturn since the 1930s. This would most certainly affect my future. If I could not sell work, I would not be able to afford to keep my studio running or buy materials to make more paintings. I would be unable to continue my practice as an artist.

I had enjoyed a certain amount of success with my work since returning to London in 2003 and had hoped this might continue, but unfortunately in the current financial crisis, this optimism proved short-lived. It was going to be a struggle to survive in such an economic climate.

Opportunities for sales became harder to find as collectors put purchases of artwork on hold with the downturn. One project I had been negotiating since the beginning of the year failed to materialise due to the uncertainty of the financial climate and this hit me hard. I had anticipated selling a consignment of paintings to a client in Moscow.

Green/Anthracite. 2009. Acrylic on canvas. 120 x 115 cm

Indeed, I had been relying on selling the paintings (perhaps unwisely). As the deadline approached for the purchase in September 2008, the economy worsened by the day. The stock market in Moscow was in turmoil, and economic conditions around the world and in the banking sector deteriorated rapidly, so the buyer pulled out at the last minute. It was a real blow. I knew that in such a climate, it would be difficult to sell paintings. The art world, like the financial world, moves in cycles. Inevitably, the markets would recover but somehow I had to keep afloat until conditions improved. It would require all the lateral thinking I could muster, but artists are adaptable creatures and can usually find a way to work through all kinds of adversities.

I had received financial support from Arts Council England on two occasions over the previous years at crucial points in my life, so I decided to make a further application to them at the end of 2008. I did not know how I would get through the recession without funding, because my situation was by now precarious and I could no longer support myself through my practice. Quite honestly, I thought it unlikely the Arts Council would fund me a third time – it is quite rare for an artist to receive such prolonged support – but I had to try. I did not have any savings to fall back on in lean times. Also, banks were not lending to small businesses, and I had already used up my overdraft and credit facilities. We were entering the age of austerity.

This time, my grant application was specific to two exhibition possibilities with Contemporary Art Projects where I had recently shown my work: a solo show at the gallery and a group show with them in the project space at London Art Fair. I needed to be able to cover the costs of the solo exhibition and to support my practice over the coming year. I stated my case to the best of my ability in my application. Then, all I could do was hope. I received notification that the grant had been approved on 30 December 2008 and received the money to fund my project at the beginning of January 2009. I was therefore able to proceed with my plans. I knew that the financial assistance I had received from the Arts Council over the last five years had been invaluable and that I had been very fortunate indeed to have their support.

However, securing the funding for my project was not enough to guarantee its success. There were further problems ahead. A few days after the exhibition at London Art Fair, the director of Contemporary Art Projects told me she had decided to close the gallery because of the recession. This left me in an impossible position, because the Arts Council's grant had been specific to my proposal for a solo show at Contemporary Art Projects, which was now no longer viable.

I struggled to come up with ideas for an alternative venue. I asked one of the artists who worked at my studios (who was also a gallery director) for advice, and he gave me a list of galleries that might be appropriate. I started approaching them one by one. But I knew I would be lucky to find a gallery to offer me a solo show at such short notice.

One of the first galleries I contacted was studio1.1, an artist-run space in Shoreditch. The gallery is on the ground floor of a converted shop in Redchurch Street. It was on this street that Tracey Emin and Sarah Lucas rented a shop to sell their work when they first left art school in the 1990s. Following a studio visit from the gallery directors, I was offered a show at studio1.1 for the beginning of January 2010. Arts Council England agreed to the change of dates and venue, and I was finally able to continue with plans for my project.

I was elated to hear in the spring that the painting I had submitted to the Royal Academy of Arts for its annual summer show, *Broken Symmetry III*, had been accepted – surely a good omen. With this success, I felt as though I had become in some small way, part of the establishment. The Summer Exhibition has an illustrious history, and I was pleased to be part of that tradition. The exhibition had also changed a little in recent years and was now more representative of contemporary art than before.

I carried many happy memories with me from having worked at the Royal Academy on the gallery education programmes in the 1990s, so I was excited about being included in the Summer Exhibition. However, when I went to see my painting in the exhibition, I was rather disappointed to find that it had been hung at the top of a row of paintings and that a small black smudge of oil paint had somehow appeared on it. I only wished the painting could have been seen at eye level and in the same condition as it had left my studio.

Broken Symmetry III. 2009. Acrylic on canvas. 56 x 56 cm

On Varnishing Day, while chatting to Norman Ackroyd (one of the members of the selection committee) about my work, I commented how disappointed I had been at its placement. He told me there are always disappointments and maybe next time my work would be hung in a better place.

Throughout 2009, I was busy with preparations for my solo show 'Cosmos or Chaos', making new paintings and preparing a catalogue to accompany it. I invited Simon Morley, who already knew my work, to write an introductory essay for the catalogue. We had worked together on gallery education projects in the past and he had sublet my studio for a short time while I was in New York, but he had last seen my paintings nearly 10 years earlier.

In the spring, Simon made a studio visit to see my work. We talked about the ideas behind my new paintings: it was a lively exchange about the work's historical and philosophical context. Simon wanted to base his critique of my work around the tradition of the American artists I admired (Barnett Newman, Agnes Martin, Robert Ryman), along with 'the void', which is a symbol in Eastern thinking, and his own interest in Taoist philosophy. Simon's essay for the catalogue described what he thought of as some of my paintings' defining characteristics: 'Her works seem to evoke a feeling of suspension, as if what we see is a held or frozen moment within an ongoing process. This sense of simplicity is achieved through an enormous process of condensation, resulting in a level of clarity and unity that permeates the work.'

I particularly liked the way Simon described the 'suspended moment' as a movement from one state to another. The gallery's press release for the show was equally perceptive. It commented upon 'the meeting point of decision and accident' as being central to the work and emphasised the important role played by time and space in the construction of my paintings. These were useful observations.

I exhibited 14 paintings at the gallery, many of which were made specifically for the show. Hanging the work was easy, having discussed the installation plan in advance with the directors. Once the biggest painting in the exhibition, *Latitude*, had been hung at the far end of the gallery, the other pieces seemed to fall readily into place around it.

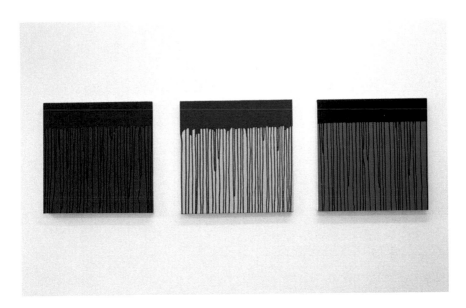

Installation view of 'Cosmos or Chaos'. 2010. studio1.1, London

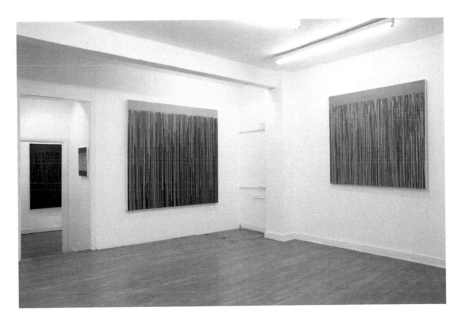

Installation view of 'Cosmos or Chaos'. 2010. studio1.1, London

The show opened during the first week of January 2010, on the coldest day of winter and at the beginning of a snowstorm, but that didn't lessen my excitement. Two of my guests were already outside the gallery door when I arrived, 10 minutes before the exhibition opened. 'Cosmos or Chaos' provided a perfect opportunity to meet up with friends I hadn't seen for years and for them to see my new work. An anonymous remark in the visitors' book commented that my paintings were 'simultaneously reassuring and disturbing', words that were entirely appropriate to my project and a fitting conclusion to events.

Artist portrait. 2009. Acme studios, The Fire Station, Bromley by Bow, London

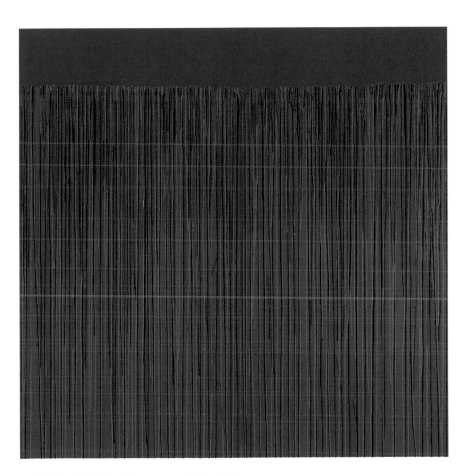

Red/Violet. 2010. Acrylic on canvas. 150 x 150 cm

So it is here, in 2010, that I close my book – at the beginning of a new decade, with all to play for. Although I have not yet accomplished all the goals I have set for myself, a career as an artist is often unpredictable and is perhaps one of the most competitive and difficult fields to aspire to. I knew from the start the challenges it would bring, and I have been rewarded and disappointed in equal measure. I have had to reconcile myself to limitations, mistakes and failures that have had far-reaching consequences, but sometimes I think that the many challenges encountered have simply made me stronger. I am, of course, increasingly aware of my mortality at this stage of life. But as to the future and what it will bring – who knows?

I continue to paint and make new work. Life is good.

Studio portrait. 2007. Acme studios, The Fire Station, Bromley by Bow, London

Photographic credits: